Creative Watercolor

Creative Watercolor

A STEP-BY-STEP GUIDE FOR BEGINNERS

Ana Victoria Calderón

QUARRY

Brimming with creative inspiration, how-to projects, and useful information to enrich your everyday life, Quarto Knows is a favorite destination for those pursuing their interests and passions. Visit our site and dig deeper with our books into your area of interest: Quarto Creates, Quarto Cooks, Quarto Homes, Quarto Lives, Quarto Drives, Quarto Explores, Quarto Gifts, or Quarto Kids.

First Published in 2018 by Quarry Books, an imprint of The Quarto Group,
100 Cummings Center, Suite 265-D, Beverly, MA 01915, USA.
T (978) 282-9590 F (978) 283-2742 QuartoKnows.com

Quarry Books titles are also available at discount for retail, wholesale, promotional, and bulk purchase. For details, contact the Special Sales Manager by email at specialsales@quarto.com or by mail at The Quarto Group, Attn: Special Sales Manager, 100 Cummings Center, Suite 265-D, Beverly, MA 01915, USA.

10 9 8 7 6 5

ISBN: 978-1-58923-969-2

Digital edition published in 2019

Library of Congress Cataloging-in-Publication Data

Names: Calderon, Ana Victoria, author.
Title: Creative watercolor : a step-by-step guide for beginners / Ana Victoria Calderon.
Description: Beverly, MA : Quarry Books, 2018.
Identifiers: LCCN 2018027495 | ISBN 9781589239692 (trade pbk.)
Subjects: LCSH: Watercolor painting--Technique.
Classification: LCC ND2420 .C34 2018 | DDC 751.42/2--dc23 LC record available at https://lccn.loc.gov/2018027495

Design and Page Layout: Allison Meierding
Photography: Maureen M. Evans

Printed in China

To my past, present, and future students,
for following your curiosity and knowing
the importance of spending your precious time
doing something you love.

You have done more for me than you
could possibly imagine.

CONTENTS

INTRODUCTION

Painting means so much to me. It's a delightful companion I can always rely on, a soothing, yet stimulating, activity that transports my mind to the most relaxed state. I'm thinking about my next move while repeatedly stroking my paper with my brush.

Experiencing the movement and flow of watercolor is a beautiful and rewarding sensation. The more you paint, the more you learn to trust the process and appreciate that watercolor dries in mysterious ways. Texture, flow, surprises, timing, and an almost mathematical way of thinking is implied when painting with watercolors. This medium has its secrets; its translucent nature makes layering completely different from other mediums. We must paint in a strategic manner to achieve interesting results while letting the medium do its magic. We know, and embrace, that there are some results we won't able to control completely.

This may sound a bit intimidating or complex; watercolor definitely is unique and has an approach all its own. But the good news is it's easier than you think! All you need to know are a few basic techniques, some imagination, and, in my opinion, the spirit of experimentation and being happy just playing around to achieve some truly magical results. Keep in mind that there are many ways to use your watercolors, and there are no rules. In this book, I teach basic techniques that have worked for me and my illustrative style, followed by step-by-step activities and ideas for projects you can do at home.

You might think that someone who paints for a living—this is my full-time job—doesn't have any room left for personal projects, but you'd be mistaken! Some of my favorite watercolor projects are the ones I've created for my day-to-day life. Making personalized place cards when friends come over for brunch, seeing the menus I painted for my best friend when I arrive at my table at his wedding, watching my family's reactions when they see my handmade Christmas cards, gifting my friend the painted and framed name of her newborn child to hang in the baby's room and knowing it's something she'll see throughout her childhood . . . all these projects make my heart glow and add sentiment to special occasions. I'll illustrate ideas and motifs you can apply to your life's special moments to make them memorable with your own handmade projects.

Nature has always been a great source of inspiration: Organic shapes, colorful subjects, and textures encourage us to observe and attempt to re-create versions of our own. Although I demonstrate specific motifs in this book, including daisies, roses, leaves, beetles, butterflies, and berries, I highly encourage experimentation. (Experiment is my favorite word when it comes to teaching watercolor!) Use what you learn here, continue to develop subjects on your own, and find a personal style.

CHAPTER 1
ESSENTIAL SUPPLIES

- - - - - -

WHEN PAINTING WITH WATERCOLORS, you can keep it simple with a paint set (that will last for years) and paper—or be an avid collector, like me. Supplies are like candy, they're colorful, fun, and sometimes you just can't get enough. Whether you're keeping it simple or love to play around with art supplies and mix it up, this chapter will give you a good overall view of what you need to know about this medium. I also share some of my favorites brands and tips on how to mix color.

WATERCOLOR PAINTS

Watercolors are an incredibly versatile art medium. Although they come in a few different forms, the key characteristic they all share is that they can be reactivated with water on a palette even if they've dried completely. Because watercolor paints contain very few ingredients, they dry true to the pigment in each color.

For the activities and projects in this book, you can use any or all the watercolor paints described here—either on their own or mixed together. I like to create my own palette for each project by using some of each type. Sometimes, I like how a pan paint works with a tube color that I've mixed with a vibrant liquid. The sky's the limit!

In the chart on the right-hand page, I summarize the pros and cons of each paint type and mention some brands I like to work with. I encourage you to experiment—try out new paints and brands or work with what you have—to find which types and brands work best for you.

Pan Watercolors

One of the most widely available types of watercolor, pan water-colors are small, square cakes of dried watercolor paint that are typically sold as a set in a metal or plastic box. The pans can also be purchased separately to add colors to a set. Pan watercolors are handy and travel well, can last for years, and the boxes they come in usually include a mixing palette. To activate them, add a bit of water to the color you want to use.

Tube Watercolors

Tube paints can be purchased in sets or individually. I love working with a pan set as my base, then acquire tubes when I find colors that complement the ones in my set. The main difference between pan and tube colors is that tube paints are creamier and smoother. To use, just open the cap and squeeze paint onto your palette. Don't worry about needing to use all the paint you've squeezed out during one session; you can always keep it on your palette and add water later to re-constitute it.

Liquid Watercolors

If you're looking for intensity and vibrance, liquid watercolors can give your paintings a real punch of color. Because they're usually dye-based rather than pigment-based, they're extremely concen-trated and offer a range of bright, bold colors, including fluorescents.

PAN PAINT TIPS

- - -

- To thoroughly moisten pan paints so they're easier to load on a brush, place a drop of water on each color you want to use and let it sit for a couple of minutes.
- To keep your pan colors pure, wipe them with a clean damp sponge or paper towel as you're working.

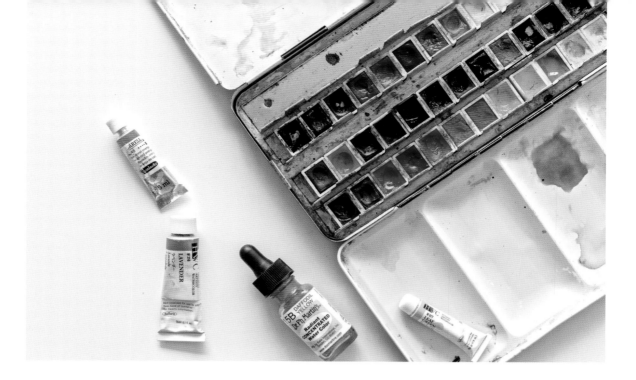

WATERCOLOR PAINT TYPE	PROS	CONS	RECOMMENDED BRANDS
Pan	• Handy • Easily portable • A convenient way to start with a variety of colors	• Colors can get messy as you mix • Set may not include all the colors you want	• Kremer • Schmincke • Sennelier • Winsor & Newton
Tube	• Colors stay clean in the tube • Well-suited to painting large areas • Paints handle smoothly	• Will dry out if the cap is left off for too long, or if the paint is old, making it difficult to squeeze from the tube	• Holbein • Winsor & Newton • Daniel Smith
Liquid	• Vibrant colors • A little paint goes a very long way	• Color intensity can make it difficult to create gradients or soft transitions • Will stain if not diluted • Poor lightfastness	• Dr. Ph. Martin's

They usually come in small glass bottles with a dropper. Keep in mind that although these paints are liquid, because they're so concentrated they must be diluted with water, then tested on scrap paper before using. You can use them on their own, on a separate palette, or mix them with your pan or tube paints.

Liquid watercolors were originally formulated for use in graphic work or illustration, with artwork that's scanned or photographed for reproduction and archived in dark storage, so their colors can fade over time, particularly when exposed to light.

COLOR AND WATERCOLOR

Color brings feeling and intention to our artwork. Here, we look at how the color wheel can be used to learn about the relationships between and among colors and creating color mixtures and palettes.

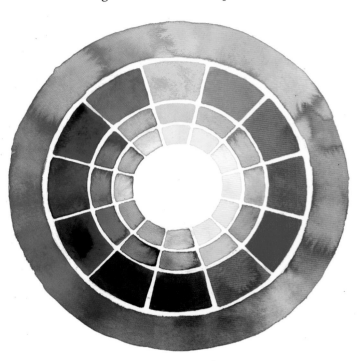

The Color Wheel

With watercolor, it's possible to create every color and value you can think of with just three colors, the primaries: yellow, red, and blue.

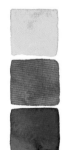
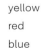

1 The color wheel uses the three **primary colors**—yellow, red, and blue—to create an entire rainbow. Every shade you can think of!

> yellow
> red
> blue

2 When we mix any two of the primary colors together, we get one of the **secondary colors**.

> orange (red + yellow)
> green (yellow + blue)
> purple (red + blue)

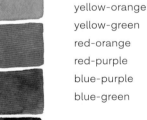

3 When we mix a secondary color with a primary color, we get one of the **tertiary colors**.

> yellow-orange
> yellow-green
> red-orange
> red-purple
> blue-purple
> blue-green

Try painting a color wheel of your own. Be sure to use only yellow, red, and blue paint so you'll get plenty of experience mixing colors. It doesn't have to be perfect!

Color Schemes

Color theory offers us countless ways to mix and group colors. Here are some of my favorites.

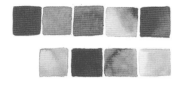

Monochrome Schemes. I especially like to practice monochromatic painting with watercolor. Combining just one color of watercolor paint with increasing amounts of water can yield a variety of values. Here, I used red-orange to show much how one color can vary when adding "white." When painting with watercolor, white is our paper, so adding more water can give us a range of increasingly lighter tints. (See page 26 for more details.)

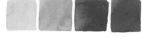

yellow, yellow-green, green, green-blue

Analogous Schemes. Analogous color schemes are found near each other on the color wheel. These are the simplest and most foolproof way to mix colors. They're in perfect harmony and pleasing to the eye. There isn't much contrast among them, as they're found on the same side of the color wheel.

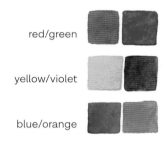

red/green

yellow/violet

blue/orange

Complementary Schemes. These pairs of colors lie opposite each other on the wheel. The term "complementary" means that each color contains none of its partner's color, so they're complete color opposites. Pairing them creates contrast, because each makes the other stand out. When you mix two complements together, you compromise their purity—a great technique for creating rich color mixes. For example, if we mix a bit of green into red, we'll get a darker, more toned, red, like a brick red. This is how it's possible to achieve an amazing variety of shades using just primary colors as our base.

Temperature-Based Schemes. Colors can also be categorized by temperature. **(1) Cool colors** are on one side of the color wheel; **(2) warm colors** are on the other. A color's temperature can influence a painting's general mood, the time of day depicted, and even emotion. Warm colors are usually associated with happy feelings, glowing sunlight, energy, positive thinking, and earthy palettes, while cool colors make us feel calm, meditative, cold, melancholy, tranquil, and quiet. I also like to include **(3) neutral colors** when mentioning temperature; they aren't typically associated with specific feelings.

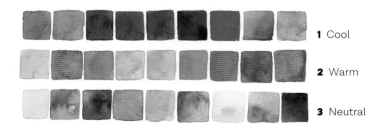

1 Cool

2 Warm

3 Neutral

Color Palettes

I created the palettes below by first choosing three concepts. I thought of colors that could relate to them, then painted swatches and a simple gradient for each one.

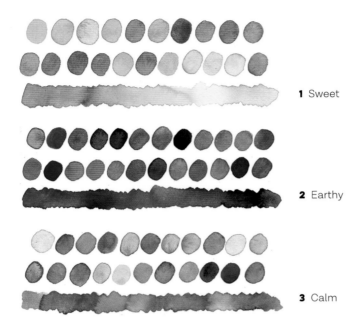

1 Sweet

2 Earthy

3 Calm

Making color boards like these is also great for inspiration, and, it's always nice to do before a larger project so you (or your client) can get an initial idea of the look and feel of the artwork. Try it out!

PAPERS

There are so many options for watercolor paper! They all work, but of course some are better than others. It all depends on your budget and personal preference. Just make sure you're using actual watercolor paper. The amount of water used in watercolor techniques requires a certain kind of weight and composition, so regular sketchbook paper won't do.

Paper has many variables. Weight, grain, individual sheets, boards or pads, content, texture, and color/tone are a few to consider.

- **Weight and Fiber Content.** Basically, the heavier the paper is, the more water it can pick up without warping. Quality watercolor paper should also be composed of cotton; some less-expensive papers have other fibers mixed in. A nice weight for illustration-style watercolor is 140 lb (300g/m²).

Watercolor paper in three standard textures—hot press, cold press, and rough—and a watercolor block and spiral pads.

- **Texture.** The terms "hot press," "cold press," and "rough" are typically used to describe various types of watercolor papers. Hot press is smooth, with little or no texture. Some artists prefer this type because it's great for adding fine details. Others prefer cold press or rough paper because their textures evoke a classic watercolor look that also works beautifully with washes. I really don't have a specific preference for texture. I switch between hot press and cold press, depending on the look I want to achieve, my mood, and the project I'm working on.
- **Format.** Personally, I like using watercolor pads. Spiral pads are great because they allow you to work on multiple projects, so you can pick up on one while taking a break from another. Having a watercolor block—a pad with gummed edges—is also nice because your paper will always be stretched, but in that case you can only work on one project at a time. Moleskine has great watercolor paper sketchbooks in a range of sizes. These are great for carrying with you everywhere.

I highly recommend experimenting and testing out different papers until you find one that feels right!

BRUSHES

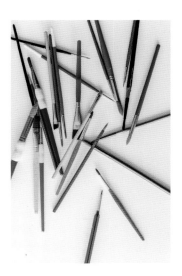

Choosing the right brushes is also a very personal choice. The type of brush you use will directly affect the appearance of the strokes.

I like round synthetic brushes. A large brush (size 10) is great for filling out larger areas, while having a size 3 brush and a 0 lb or even 000 lb on hand is perfect for adding details and painting small, tricky areas that may be challenging to get into.

Most watercolor round brushes have a pointy tip, which lets us achieve different stroke sizes just by altering the amount of pressure and the angle of the brush. This versatility is especially handy for lettering activities (see page 107).

It's always a good idea to include flat brushes, too. They're great for filling out larger areas without having to thin out paints with excess water, and they also work well for the spatter effect (see page 36).

EXTRAS

In addition to basic watercolor supplies, always have some basic office supplies on hand, such as pencils, sharpeners, erasers, rulers, and glue.

Watercolor is a noble medium that works well with many others. If you have any inks or liquid paints lying around, by all means, experiment. There are no rules—just play! Here are some options.

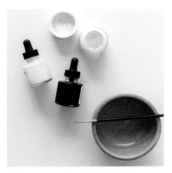

Black & White Inks

Ink is the perfect medium to complement watercolors. It's particularly effective when adding final details over paintings or when you want to make a particular area more opaque. Acrylics or gouache also work well with watercolors, but I prefer the liquid texture of ink.

Gold Ink or Paint

There are a few types of gold paint you can use with watercolors: ink, acrylic, or watercolor all work well. Metallic paint, in general, is fantastic for adding final details to make paintings extra special. My favorite brand of metallic watercolors is Kremer, which are handmade and extremely high quality. Winsor & Newton has a great line of metallic inks, as well.

Glitter, Metallic Powder & Crystal Embellishments

This book offers some cool ideas on how to add fun decorations and embellishments to your projects. High-quality glitter, metallic powders, and rhinestones are really fun, simple ways to add special touches to your projects without having to use complicated equipment or techniques. You'll also need glue or some sort of adhesive and a straw or tweezers when handling these delicate materials.

Markers & Pens

Markers, Pigma Micron pens, gel pens, and extra drawing supplies can be great complements to your watercolors. This book shows a few different ways to incorporate these mediums into your paintings.

Ribbon & Twine

Hemp, jute, straw, leather twine, and ribbon are beautiful ways to pack up your watercolor paintings and add a little something special to stationery projects.

Washi Tape

Washi tape is not only supercute, it also comes off easily without ruining the paper. In this book, we use washi tape for our tracing trick (see page 66); it's also great for decorating envelopes when you're packaging artwork.

Stickers

I always like having simple stickers in my studio for adding extra details to DIY projects. These silver hearts are especially cute for sealing envelopes!

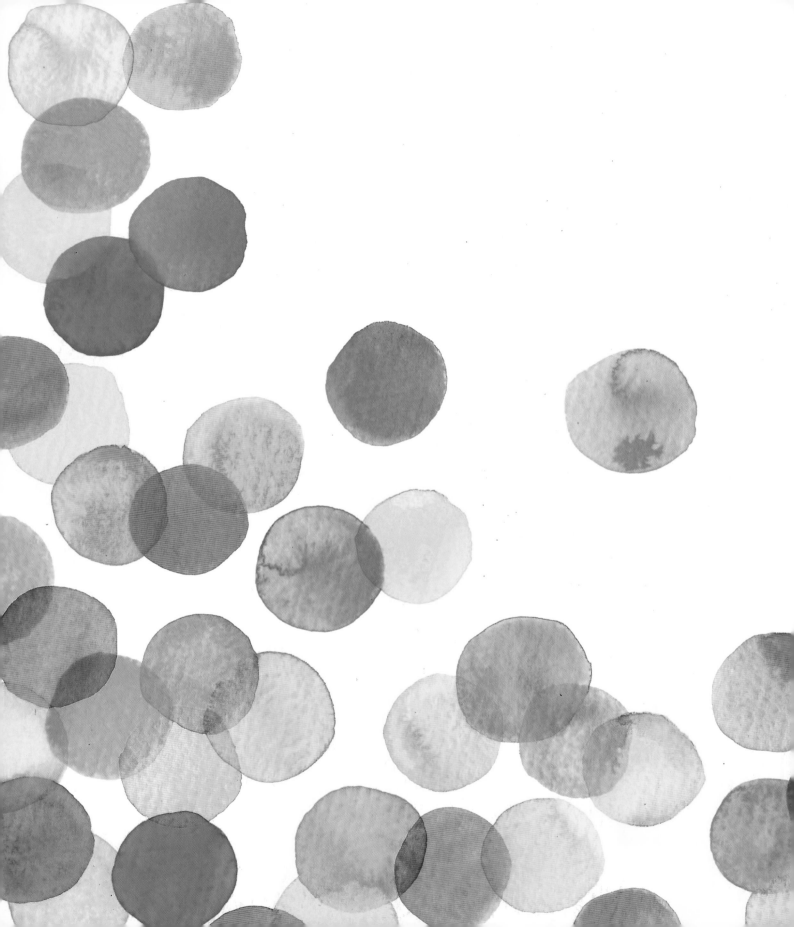

CHAPTER 2
BASIC TECHNIQUES

WATERCOLOR IS A MEDIUM LIKE NO OTHER. Yes, you can pick up paints and begin to use them intuitively to see what happens—and you might get lucky or you can do these simple activities to help you understand how the medium works. Watercolor's nature is translucent, there is a lot of timing and thinking that goes into it before we begin painting. There are also many styles and techniques. In this chapter, I will show you tips on how to paint using more of an illustrative style. Let's get started!

WATERCOLOR WARM-UPS

Watercolor can be intimidating for beginners, and even some experienced artists find it challenging. In fact, throughout my years teaching the medium, I've met many talented acrylic and oil painters who have a hard time switching over to watercolor because it just works *so* differently. With the simple warm-up activities in this chapter, you'll begin to understand how watercolor really works, get comfortable with your paints, and hopefully come up with ideas for new creations.

Wet on Wet

There are a couple of basic ways to paint with watercolor. The wet-on-wet method is typically used for painting landscapes, simple skies, or soft watercolor washes because the effect gives us a nice *flowy* look that can be applied in different ways. Basically, we're adding wet paint to a wet surface. Here's a simple activity that can help familiarize you with this technique.

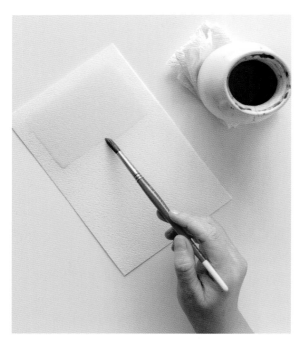

1 Start by wetting your brush with plain water and "painting" two rectangles.

2 The rectangles will be hard to see because there's no pigment, but if you tilt your head a bit you will be able to see where you applied the water.

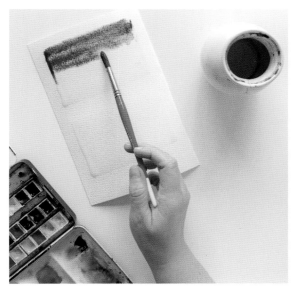

3 Pick up moistened paint from your palette and add color to the top wet rectangle. In this image, I'm simply sliding my brush from side to side.

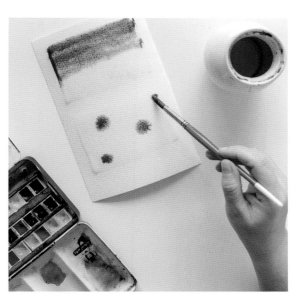

4 In your second rectangle, just add dabs of paint. This activity is great for beginning to gauge the amount of water and paint you prefer to use.

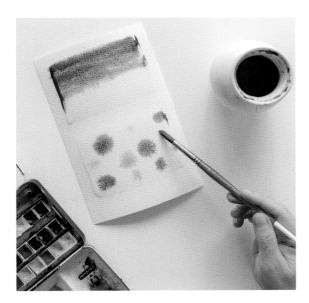

5 Here, our paint has begun to dry. See how different it looks? When painting wet on wet, we don't have much control over how our paint reacts. This is a beautiful aspect of this technique. Watercolor dries in mysterious ways, and we can achieve gorgeous textures just by letting the paint dry naturally.

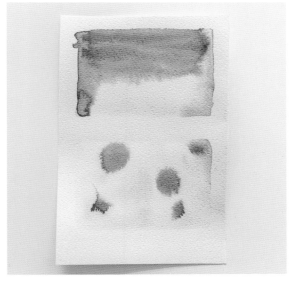

6 Here, our paint has completely dried, and it's changed even more! It's normal for colors to appear less vibrant once they've dried. Interesting textures also appear, which makes wet on wet a great technique for adding texture to painted shapes.

Wet on Dry

Wet on dry is used to achieve more precise and defined shapes. This is the technique I like most, and, in general, most illustration-style watercolors are achieved using wet paint over a dry area.

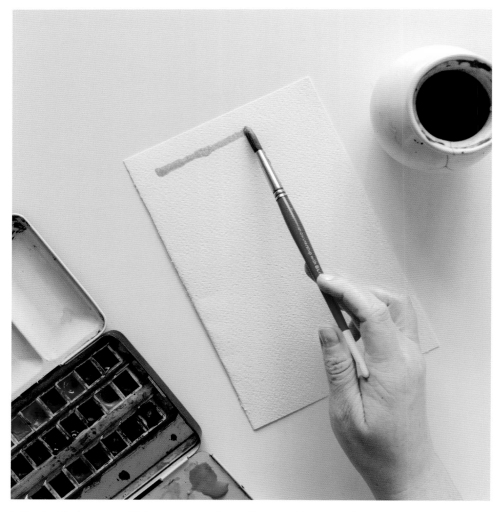

1 Start with dry paper. Pick up some moistened paint with a large brush and simply begin to paint.

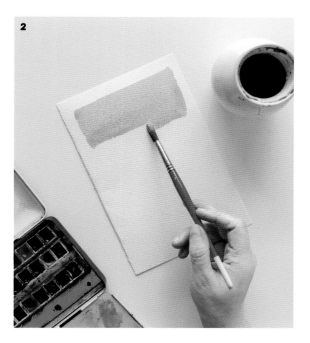

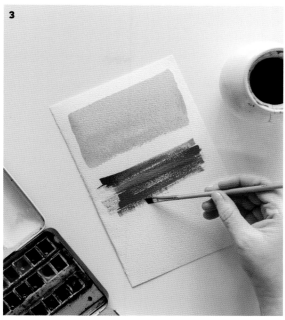

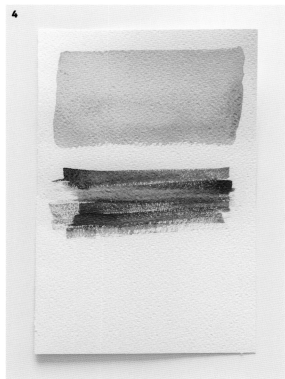

2 The ochre paint I used here is quite watered down. The opacity of your paint will depend on how much water you mix in.

3 You can also try using drier paint. I used the minimum amount of water to get my paint going, but you can see we get a completely different texture, a sketch-like finish. Some artists use this technique as a signature style. I've seen it used in fashion illustrations quite often!

4 Now the paint is completely dry. Again, notice how the colors tend to fade and can look quite different at this point.

Transparencies

Transparency is watercolor's most important quality. When working with watercolor, you always need to remember that water equals white. By this, I mean a few things:

- *To make a color lighter, you must add more water instead of mixing it with white paint.* Mixing watercolor with white paint makes it appear chalky instead of translucent.
- *When we paint with watercolor, the white of the paper is our true white.* In most cases, if we want an area in a painting to be completely white, we paint around it so the white of the paper shows through. You'll discover this as you try some of the other activities in this chapter.

The purpose of the transparency exercise is to explore all the different values that can be achieved by mixing increasing amounts of color into water.

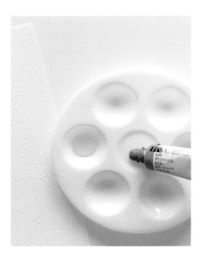 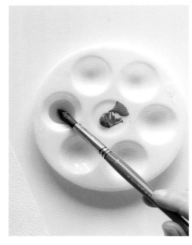

1 To start, I recommend choosing a darker color, like a deep blue or red.

2 Put a few drops of clean water on your palette. Pick up just a tiny bit of paint on your brush, then mix it into the small puddle of water.

3 This is your first value—an extremely light, transparent red.

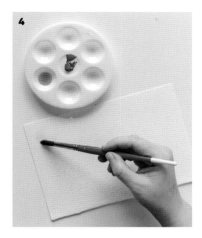

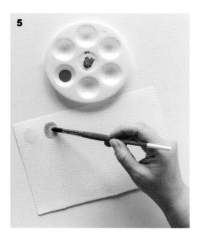

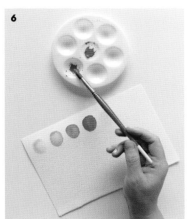

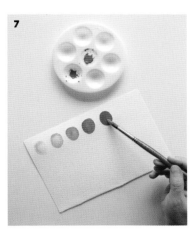

4 Paint a circle on your paper using this watery mix.

5 Go back to your palette and mix a little more paint into your puddle of water. Be mindful of how much you're adding. You're aiming to create red in a range of values, so it's important to add paint little by little. Paint your second circle.

6 Repeat the process, adding a little more paint each time to create a slightly darker value, then painting a circle.

7 As you gradually add more paint (which means the proportion of water in the mixture decreases each time), your original puddle will start to look darker and thicker, and your circles will look increasingly opaque. Continue painting circles until your paint is as thick and opaque as it can get. Look at all the values you can achieve by mixing just one color with different amounts of water.

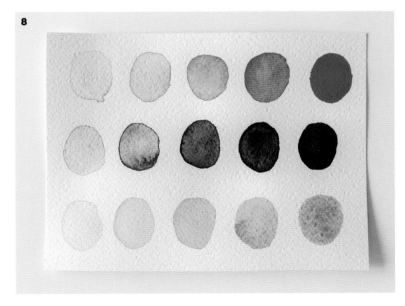

8 This activity isn't as easy as it looks. Repeat as many times as needed to achieve your goal of a subtle and gradual transition from an extremely light to an extremely concentrated value. Also, try it with different colors. It's a great way to practice and get to know your paints. The pigment in each paint color is different, and you'll begin to discover how the values within each can work for you. Lighter colors like yellow are harder to practice with, while darker ones like blues, purples, browns, and reds are great for getting started!

Building Up Color

This activity will help you practice building up color from plain water to a saturated paint mix. This exercise is similar to the one for transparencies, in the sense that we'll be using just one color to achieve different values (see page 26), but in this case we're looking to create a seamless effect, popularly known as "ombré."

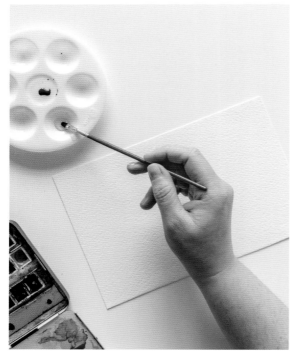

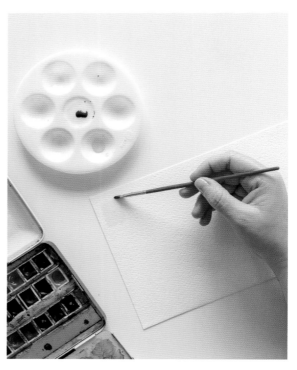

1 Start with a dry area of watercolor paper. Drop a small puddle of water into your palette and a dab of concentrated paint right next to it. I used a medium-sized brush and a bit of green tube watercolor.

2 Pick up a bit of water with your brush (no pigment yet) to get you started. Begin painting your strip (it will look transparent on the paper).

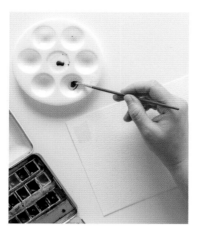

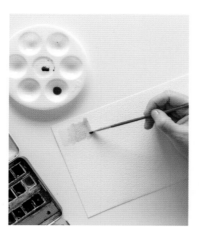

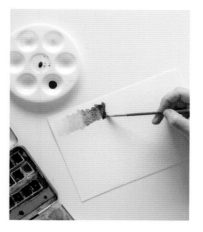

3 Add a tiny bit of pigment into your puddle of water, make sure to be mindful of how much paint you are adding. You want this process to be subtle and work up slowly.

4 Continue by painting where you left off with the transparent water.

5 Repeat the process by adding a bit more paint to your initial puddle of water each time. Before picking up more color, remember to rinse and pat your brush on a piece of cloth or paper in between so it's clean.

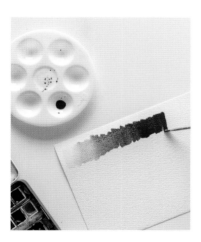

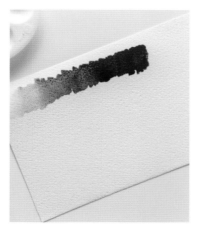

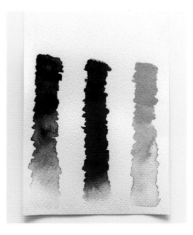

6 By the time you reach the end of your strip of paint, your watercolor mix should be quite thick and the paint should appear concentrated and as opaque as it can get.

7 Now you have a nice transition from unpigmented water to concentrated paint. The goal is for the process to be delicate, with no harsh transitions from one value to the next.

8 Repeat as many times as you wish. Try this activity a few times to experiment with different colors and to begin to feel comfortable building up color.

Creating Gradients

This activity is similar to Building Up Color (see page 28), but instead of working with plain water and different values of one color, we'll be working with two colors and slowly transitioning from one to the other. It's a great technique for painting skies and sunsets!

Be sure to use colors that are close together on the color wheel to create harmony, otherwise, your gradient will appear muddy. I used green and yellow; other good combinations are blue to purple, red to orange, or blue to green.

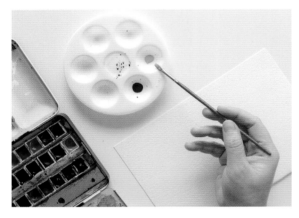

1 Mix two separate colors side by side. The paint should be neither too diluted nor too concentrated; aim for a 50/50 mix of water to paint for each color.

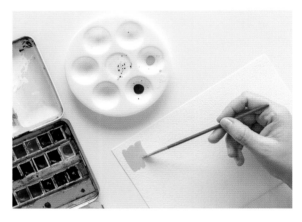

2 Start painting your strip of color using pure yellow paint.

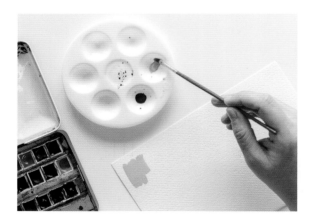

3 Clean your brush. Pick up just a little bit of green paint and mix it into your yellow mixture.

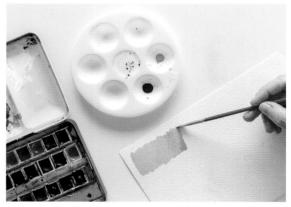

4 Pick up where you left off on your first brushstrokes. The transition from yellow to a slightly greener yellow should be soft and subtle. Try to avoid harsh changes in tone so the gradient doesn't look choppy.

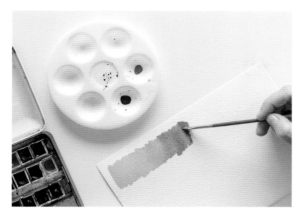 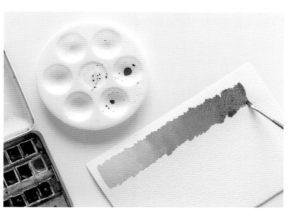

5 Little by little, keep adding a bit more green to your original yellow mix. In this exercise, the real work happens in the palette.

6 By the end of this paint strip, your original mix should completely transformed into pure green and you'll have a beautiful gradient of color.

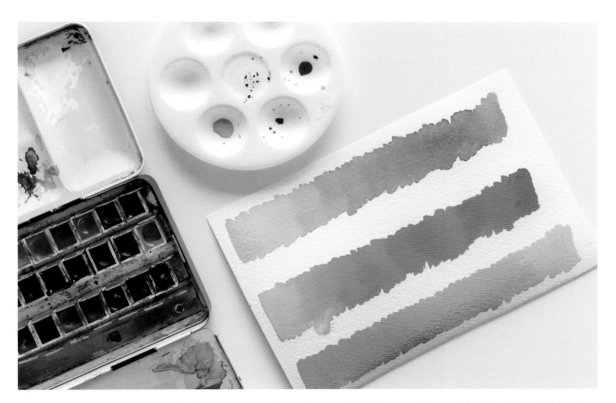

7 Try this as many times as you feel necessary, and experiment with different color combinations. You might get ideas for new paintings!

Fine Lines & Thin Strokes

A painting is finally complete when we add detail. To achieve a professional look, fine lines and thin strokes are essential. Gaining control of your detailed brushstrokes may take a while, and these activities will help you practice and gain confidence.

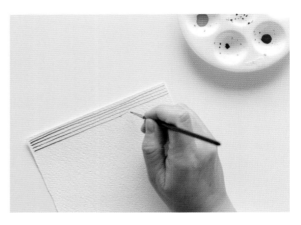

1 Pick the brushes with the smallest tips you can find. I like using a size 0, or even 000, depending on how fine I want my lines to be. You may want to experiment with a few brushes until you find one that feels right.

2 Start painting fine lines horizontally across your page in one controlled movement. This may appear to be easier than it looks! Don't worry if your hand shakes or your strokes are wobbly, at first. You'll get better the more you practice.

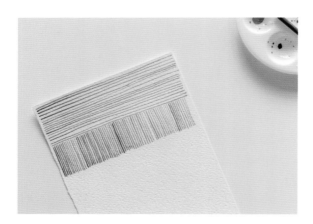

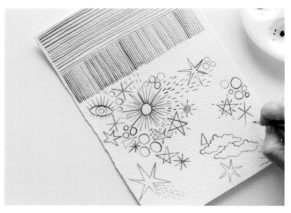

3 Now try painting smaller vertical lines underneath your horizontal lines. This will be a breeze after painting longer lines! The shorter the strokes, the easier they are to control.

4 Start doodling, just as you would with a pen but using your fine-tip brush. Trace different shapes—whatever comes to you! Make sure to include lots of round shapes, too. Doing this will help you gain control of your thin lines and build more confidence in your brush strokes when adding detail in upcoming activities.

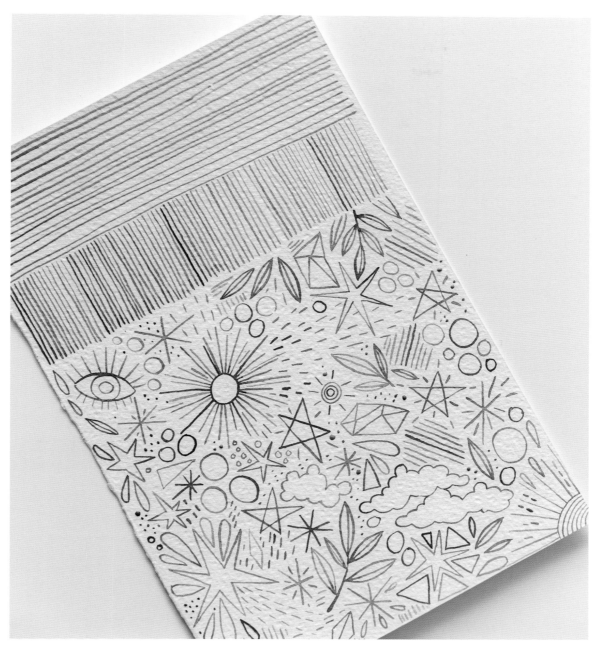

5 Keep it going until you fill the page. This is a great activity to come back to or use as a warm-up before adding fine lines to an illustration.

Getting Precise

This activity is a simple way to practice painting around edges in a nice, controlled way.

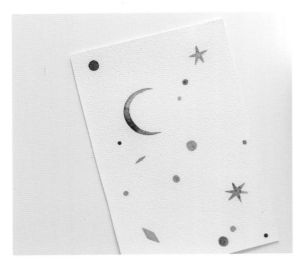

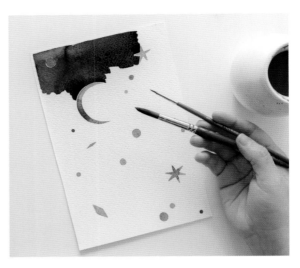

1 Paint simple shapes around your dry piece of watercolor paper. I chose circles, stars, and a moon, but you can choose any simple shape you like. Triangles, diamonds, hearts, and squares can work, too.

2 Using a different color, begin painting around these shapes. You'll want to use two different sized brushes here: one for smaller, more-detailed areas that are tough to reach, and a larger round brush when you're filling out larger areas.

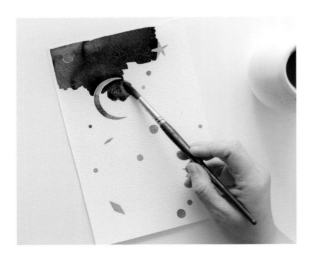

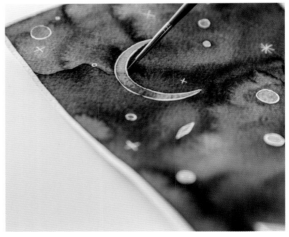

3 Make sure to prepare enough blue paint (about 50/50 mix of water to watercolor). You'll have a better flow, keep the blue area moist, and can pick up where you left off each time.

4 Get really close to each shape. The goal is to paint as closely as you can without actually touching the first shape, so there are very fine white areas between the shapes and the background.

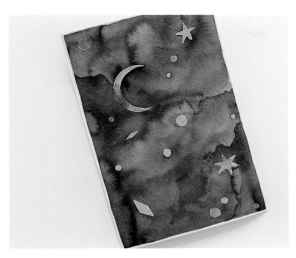

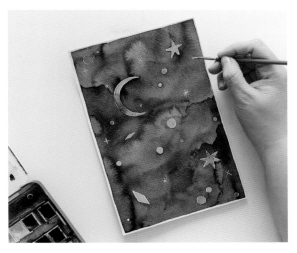

5 Another technique to practice is painting just inside the edge of your paper to create a border. This will give it a nice organic look while you keep practicing brush control. You will also start to notice beautiful watercolor textures appearing. This depends on how much water, the type of paper, and how fast you move.

6 As a final touch, add details with white ink. You can also use gouache or acrylics. I use this technique to add final details to most of my paintings.

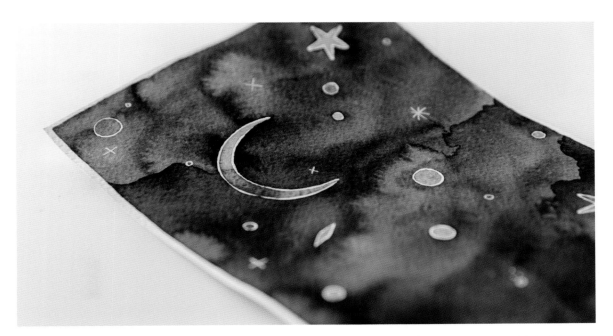

7 Repeat this simple practice exercise as many times as you feel necessary. It's a great way to get into the illustration-style watercolor groove. You might even get ideas for larger paintings.

Spatter

Spatter is a fun way to add texture to your paintings. This technique can be applied in a couple of different ways. You can use a hard bristle flat brush, or even a toothbrush, for this activity! The size of the brush and the amount of paint will give you different results.

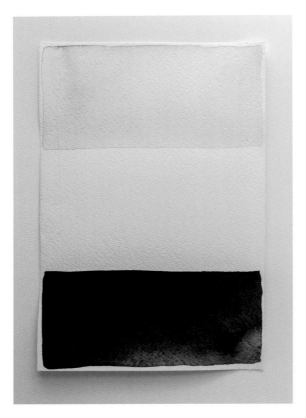

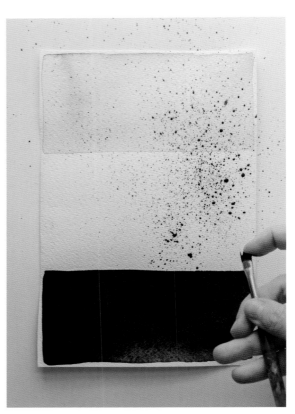

1 Begin with a few different background areas. I used a rectangle of translucent paint, a blank dry area, and a heavily painted opaque area. For the best results, make sure your first layers of paint are completely dry before adding spatter.

2 Pick up paint with your brush and begin spattering paint over your dry areas by running your finger through your brush. It's a good idea to place a scrap piece of paper under your painting. When spattering, it's hard to control where your paint lands.

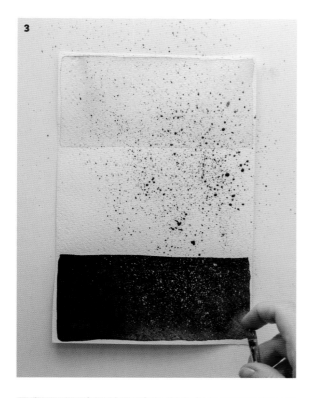

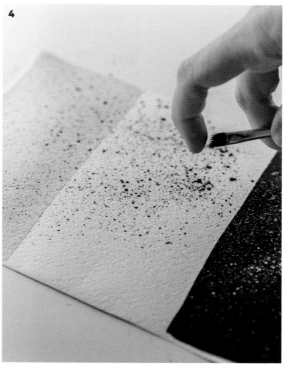

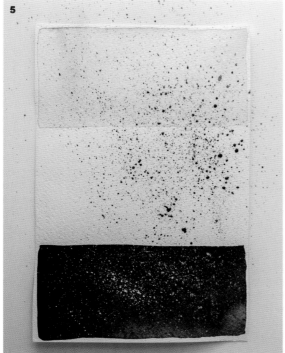

3 Repeat the same process over your darker rectangle using white ink or paint. (I use this technique to add stars to my night sky paintings!)

4 Try this a few different ways. The amount of water in your paint mix, the angle at which you hold your brush, and the proximity of brush to paper will all factor into the look of your spatter.

5 Now that you've practiced spattering, imagine different applications. For example, you can use it to decorate the backgrounds of floral paintings or as an abstract technique, maybe for texture in a landscape painting. There are endless possibilities!

Layering

Timing is a huge part of painting with watercolors. This easy activity will help you understand how layering works—and will also teach you how to be patient—while making a fun abstract painting.

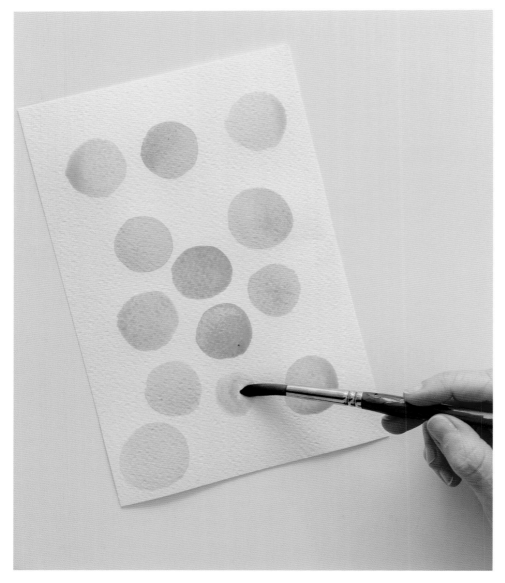

1 Using a watery mix, paint circles all over your paper. Make sure they're not touching each other.

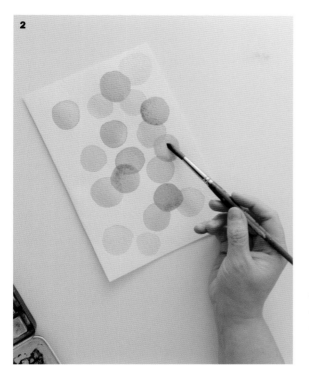

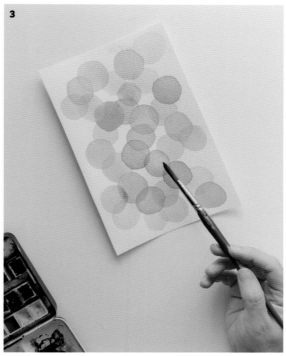

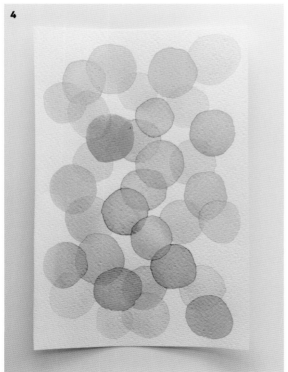

2 Wait for the first circles to dry completely and start painting more circles over the dry layers. This is also a good way to play with color. I chose a variety of warm colors, but you can try this with just one color, or even a rainbow palette, and see what happens!

3 Keep going! Be sure to use plenty of water to make your paint translucent enough. If your paint is too opaque, you won't be able to appreciate the true look of transparencies. When you use two different colors, you'll get a third color where they overlap.

4 In the end, you'll create new colors by layering circles while practicing flow and timing. It also looks pretty cool!

Getting into the Flow

This activity gets us into what I like to call "watercolor brain." Watercolors work so differently from other mediums, mainly because we must think in reverse and always be mindful of taking care of our transparent layers, adding color and opaqueness gradually. We'll also begin to add details using our fine-line skills.

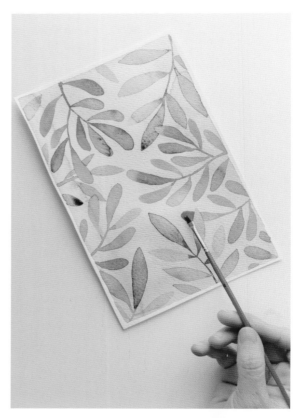

1 Using a very watery mix of paint, fill your paper with a light wash, painting just inside the edges. Think of a value 1 or 2, as we did in the Transparencies activity (see page 26). If you're using a large piece of paper, you might want to make sure your edges are glued to the pad, or tape the edges onto your work surface. The paper might begin to warp when we use a lot of watery paint like this.

2 Wait for your background to dry completely, then paint leaves over this layer. Play around with the color and styles of leaves here (we get deep into botanicals in chapter 3). Use your precision skills when painting one leaf over the other. Try to keep these layers pretty transparent, too.

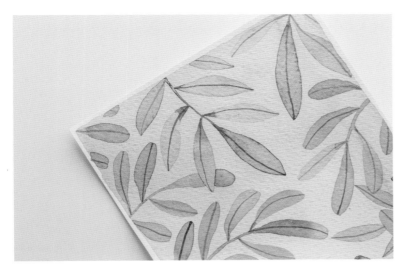

3 Once your leaves have dried, begin to add detail. Detail gives your paintings a professional look while adding direction and intention to your compositions. In this case, we're adding simple thin lines to each leaf to represent veins.

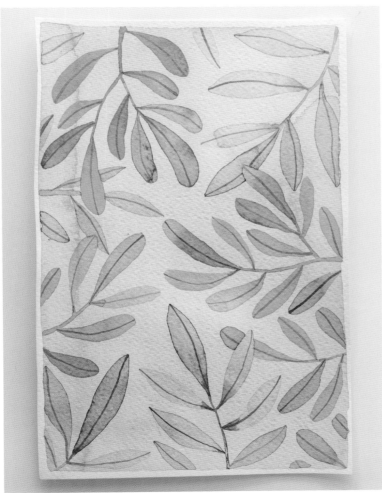

4 Your painting is finished! With this activity, we practiced working with transparencies, layering, precision, details, and fine lines.

SCANNING AND EDITING IN PHOTOSHOP

To successfully scan and replicate your paintings, I highly recommend that you learn some Photoshop basics. Photoshop is a great tool for graphic art and will come in handy if you want to do more than just individual pieces.

Below, and on the following pages, I share the process that works best for me. I've kept the guidelines and tips as simple as possible, assuming the reader will have a basic knowledge of the program. Also, please keep in mind that Photoshop has many layers of complexity, and that every image is unique, and so they may require different types and levels of adjustment or correction.

There's a wide range of scanners available; each one will make your watercolor painting look slightly different. Some will be better quality, while others might make you work a little bit harder to correct your file. The goal is to make your painting look the same as the original when you see it on the screen and in print.

1 First, make sure you've erased all pencil markings and you have a nice, clean illustration.

2 Lay your illustration flat on the scanner and proceed to scan. For print quality, make sure your settings are at 300 dpi or higher. You want a higher resolution so quality isn't compromised. If you're scanning your painting to share online, set your resolution to 72 dpi, which will give you a smaller file size.

3 Once you've your scanned image, you may notice that the colors are a bit off. Your scanned painting might look desaturated or the background may appear to have a yellowish tint instead of being crisp white. Again, it all depends on your scanner.

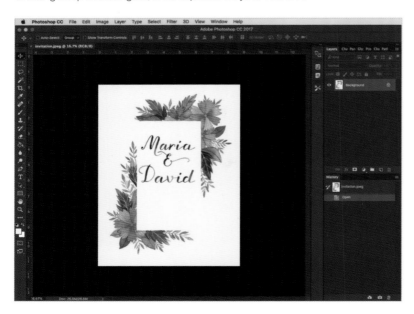

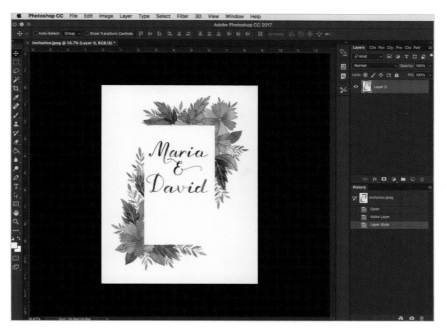

4 Open your image in Photoshop. I like to start by rasterizing the layer with the painting. Make sure your image size is 100 percent because rasterizing your layer turns your image into pixels relative to the size of your canvas. I rasterize my image because there are many editing functions that work only on pixel graphics. ***Right click on your layer > Rasterize layer***

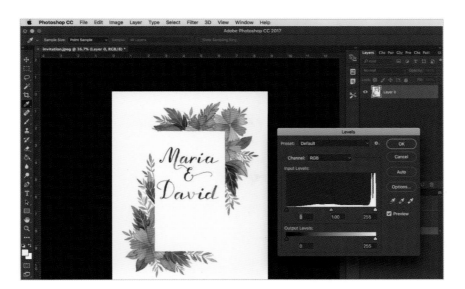

5 If I were to give one major tip for color-correcting your image, it would be to adjust your levels. Go to ***Image > Adjustments > Levels***. Levels allow you to adjust shadows, midtones, and highlights. Adjust the sliders to begin correcting. In this case, I slid my shadow arrow on the left toward the middle to darken my watercolor area, and my highlight arrow on the right toward the middle to make the background pure white.

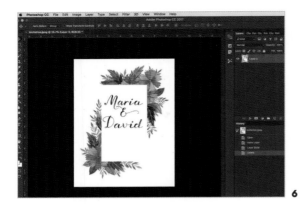

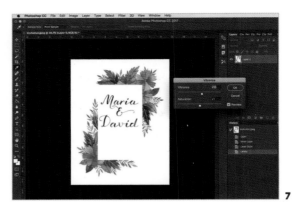

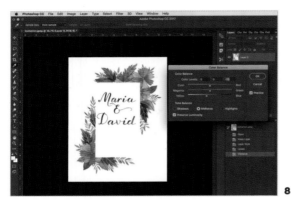

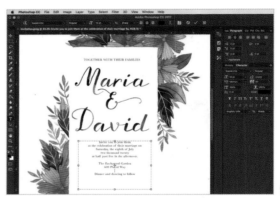

6 Notice how the yellowish background is now white and my flowers look more saturated. Again, I'm trying to get my painting to look like the original. You don't want to edit too much, otherwise, it might look awkward, or you may begin to lose those precious transparencies that we can achieve only with watercolors.

7 Sometimes, I see my art losing its vibrance when scanned. There's an easy way to correct this. Simply go to *Image > Adjustments > Vibrance* and adjust accordingly. I do this intuitively while comparing my original painting to the image on the screen. Again, this is all about observing and not going overboard.

8 Finally, my scanner tends to shift my tones cooler than they are, so I like to do just a tiny bit of color correction. All I did here was shift my slider toward yellow and away from blue. These are subtle corrections, but for me small details really matter. To adjust color, go to *Image > Adjustments > Color Balance*. Keep in mind that you may have to correct your color in different ways. It all depends on your image and the scanner you're using.

9 Since this is a wedding invitation, I need to add text for all the information relevant to the event. To add text to your design, click on the *Type Tool* in your toolbar and add a text box in the desired location. Edit size and font in the *Character tab*. I chose a classic serif font for this elegant occasion.

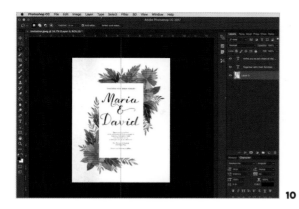

10

11

12

WHICH COLOR MODE SHOULD I USE?

— • — • —

When using web files, it's best to keep your color system in RGB mode; for print, it's recommended that you work in CMYK.

10 When designing stationery—or any layout, for that matter—it's useful to add guides to your canvas. Here, I simply dragged a guide and placed it in the center of my invitation. This helps me arrange my elements in an orderly way. If rulers aren't appearing in your workspace, go to **View > Rulers**.

11 At this point, I'm satisfied with the color and text, but when I zoom out, I notice my lettering looks a bit unbalanced. Again, the Photoshop process is very intuitive for me, just the way painting would be. Sometimes, you have to step back and look at your entire design to see if you're satisfied with the overall appearance. In this case, I felt like the word *Maria* and the ampersand were too far up and needed to be closer to the word *David*. To correct this, go to your toolbar and click on the **Lasso Tool**. Select the area you want to move by circling it with your lasso. Now you're free to move it around. In this case, I simply nudged the area down a bit.

12 That's it! I'm pretty much done editing this invitation. The cool thing is you can send this file out to all your guests digitally, or you can prepare your file to print and make as many paper invitations as you like.

If you're interested in working with watercolors digitally, I highly suggest enrolling in a graphic design or Photoshop course. What we did here is pretty simple, but there's so much more you can accomplish with these tools. You could make repeat patterns with your watercolors, design journal covers, create a print-on-demand shop with your art on prints, mugs, fabric, etc. The possibilities are endless!

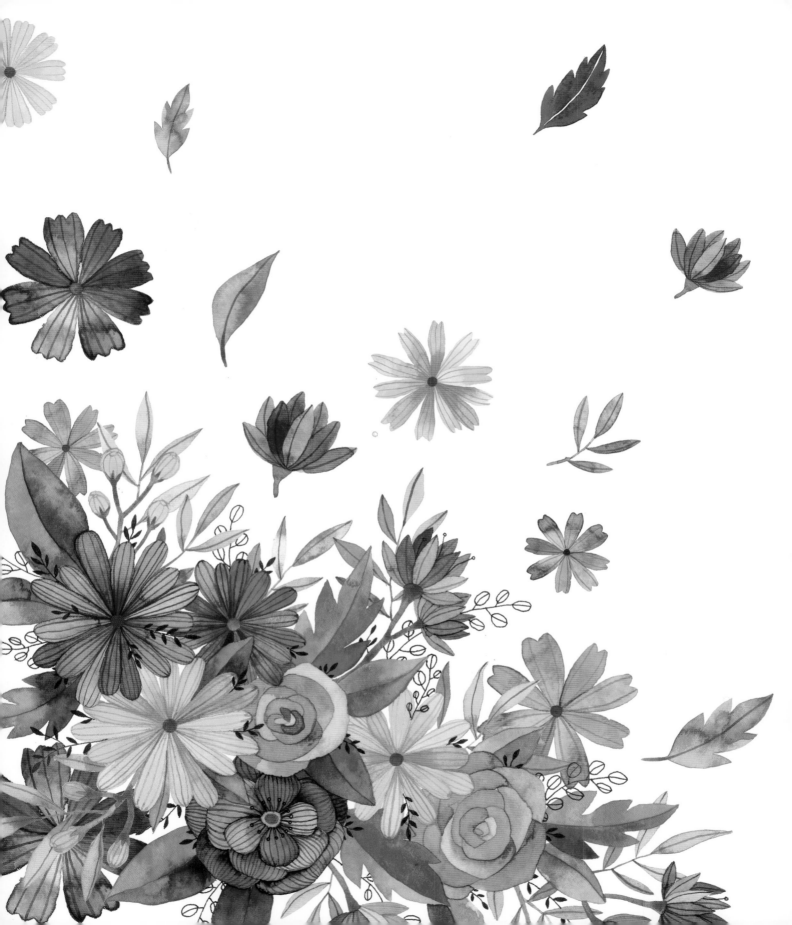

CHAPTER 3
FLOWERS & FOLIAGE

- - - - - -

FLOWERS AND FOLIAGE are two of nature's greatest gifts. They've been interpreted by artists for centuries in different forms and mediums. There are many ways to paint these beautiful forms: realistic, abstract, illustrative, loosely, or detailed. In this chapter, I teach a few different methods for painting florals and foliage. Try them out and see which ones fit best with your personal style.

LEAF STUDIES

When painting leaves, we tend to imagine the simple eye-shaped leaf, but when we actually take a close look at nature there are hundreds of different shapes, styles, and colors to be explored in this simple subject. This activity will help even experienced artists explore the possibilities of painting leaves through observation while putting new skills into practice or refining a style of your own.

Below is a photograph of different types of leaves. Choose a few as inspiration, or take a walk in nature and pick up some of your own!

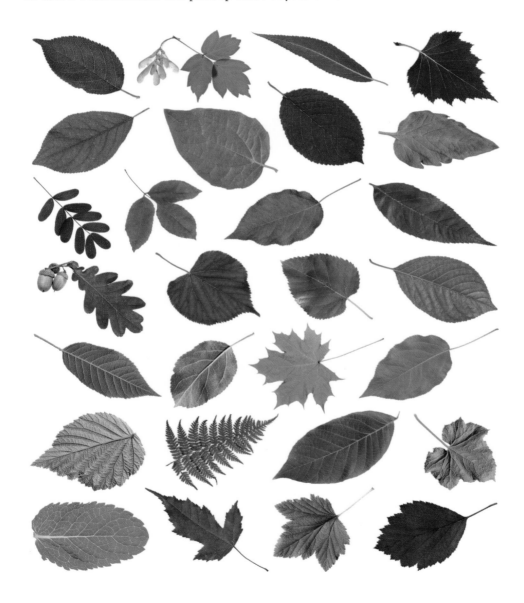

1 Once you've chosen your leaf shapes, begin by drawing simple outlines. Keep your drawings as minimal and as clean as possible. When you paint over a drawing, you won't be able to erase the pencil markings that peek though your transparent layers.

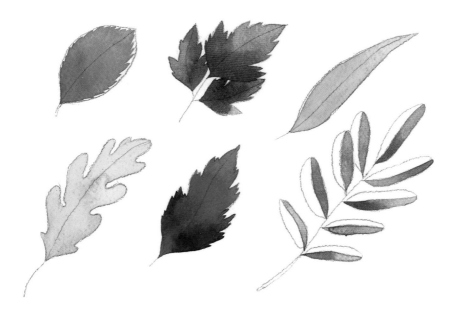

2 Paint your first watercolor layers. There are a couple of things to note here. Since we will be adding on to these initial layers, keep them pretty transparent. See how I began to add outline detail to the shape of the first leaf? This is important, because sometimes the shape of your brush does the work and you just need a simple drawing to begin with.

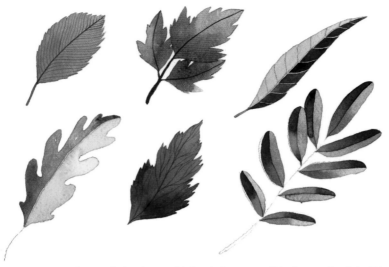

3 Our second layers are what really begin to add depth. In some of the leaves, I painted the veins over the initial layer using a bit more concentrated paint, and that's pretty much it! But you can also use negative space to get lighter tones to be our details. I used this technique in the third and fourth leaves. This basically means painting everywhere except the places you want to peek through (in this case, we want the soft yellow layers to be preserved). I also waited for one side of the leaf to dry on the last example before painting the side that is right next to it. This prevents one color from bleeding into the next.

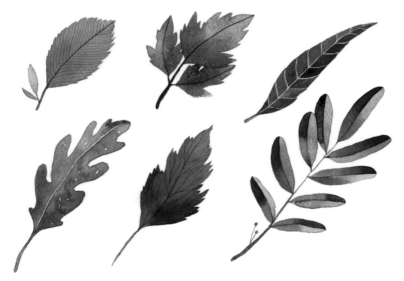

4 Add your final details. A fun tip here is to leave tiny "windows," or unpainted areas, to give some texture (see the fourth leaf). I also added some tiny branches and leaves to the stems just to play around a bit. I highly recommend choosing real leaves and making them your own with these basic painting techniques and experimentation.

A side-by-side look at how the painted leaf studies compare to the photos of real leaves.

ADDING DETAILS: STRUCTURED DAISIES

Once you've practiced transparencies and gradients and feel more confident painting fine lines, here's a motif where you can apply the simple watercolor principles you've mastered.

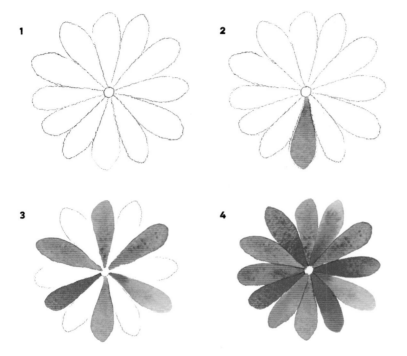

PENCILING TIPS
— — —

Once you paint over pencil markings, there's no way to erase them. So keep your drawings minimal and clean, using them only as guides. You can erase pencil markings right before painting or paint near them instead of over them.

1 Lightly draw a simple daisy shape. Start with a small circle in the center, then draw petals around it. To keep the shape balanced, draw the top and bottom petals first, then fill in the rest, adding one on each side. Try to keep your pencil markings light.

2 Begin painting in the petals. A fun way to do this is to use what you learned in the Creating Gradients activity (see page 30): Start with a darker value at the center and then gradually water it out as you reach the petal's end.

3 Continue painting the petals, skipping over the one right next to the one you just painted so they don't bleed into each other.

4 Once the first round of petals has dried, fill in the rest. You can play around with colors and values here; for example, use a couple of pinks or reds to get a nice color mix in a single flower.

5 Make sure all the petals are completely dry, then add details. Using your thinnest brush, paint fine lines along the length of each petal. This gives the flower dimension and unifies all the layers into a single shape.

6 To finish, paint the daisy's center with a circle of color.

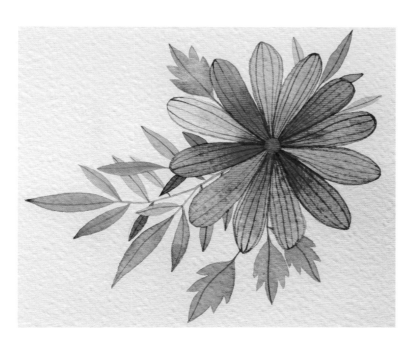

Try adding simple leaves or painting a cluster of daisies. You'll be amazed at how beautiful a layout featuring this simple flower can be!

CREATIVE CHALLENGE

– – –

Experiment by painting different petal shapes. To the right are some examples. Can you dream up your own petal designs for a daisy or a similar flower?

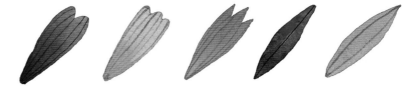

LOOSE & WATERY ROSES

This technique is popular for painting flowers. Lots of water, flowing paint in loose shapes, and light washes create breezy florals that are not only gorgeous but are also extremely relaxing and fun to paint.

The roses featured in this exercise are a classic example of this style. Try it a few times. Note that the size of the round brush will determine the look of your rose. Play around with different color combinations. The more you practice this style, the better you'll get at it!

 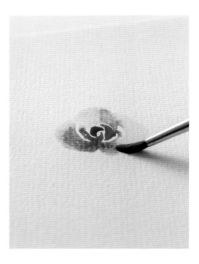

1 Load a round brush with a concentrated mix of paint. Paint a simple rosebud with three nested little half-moons.

2 Rinse your brush, pick up clean water, then lightly dab it on a cloth or paper towel to make sure it's moist enough to get your painting going but not *too* wet. Place the tip of the brush into the center of the rosebud. Pull a bit of color from the rosebud, then begin painting around it.

3 The brush should lay at a flatter angle in this step. A couple of things are happening: The width of the brush is creating the shapes of the petals, while the tip is pulling in color and creating a nice wash around the rosebud.

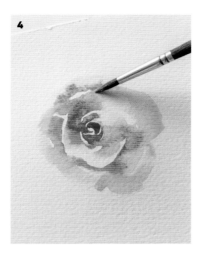

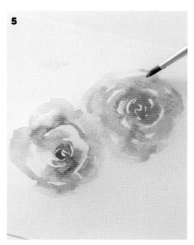

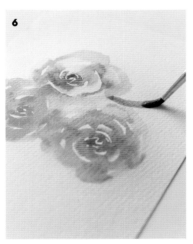

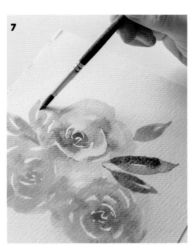

4 Continue working your way around the bud until you have a nice, full shape. Try not to make it too perfect. Nature has unique forms, and it's okay for your rose to be a bit lopsided or irregular. While the paint is still wet, experiment with adding touches of another similar color. I added a bit of orange to my pink rose.

5 Your first rose is complete! Try a composition while you're at it. Paint a second rose next to your first. Keep in mind that the water is part of the effect, so if your new rose bleeds into your first one, *that's okay!*

6 A trio of roses! This composition always looks great. Add some leaves; a round brush creates perfect pointy ones. Pick up some green paint, lay the brush flat on the paper, then paint out and lift with a straight angle to get a nice shape, finishing with the tip of the brush.

7 Paint leaves all around your roses in different shades of green.

Here are some other examples of loose and watery florals. Try adding details, like simple berries or little lines and dots of white ink for an extra touch of magic. Or use the leaf-painting technique above to create flower petals. Let your brush and imagination do the work! Experiment, experiment, experiment!

PAINTING A BOUQUET

Now that you have a few ideas for painting different flowers and foliage, it's time to create our first composition: a beautiful bouquet.

Here, we take a close look at how a larger composition is created. When painting with watercolors, it's important to keep layering and sequence in mind. You always want to start with your lighter washes and work your way up.

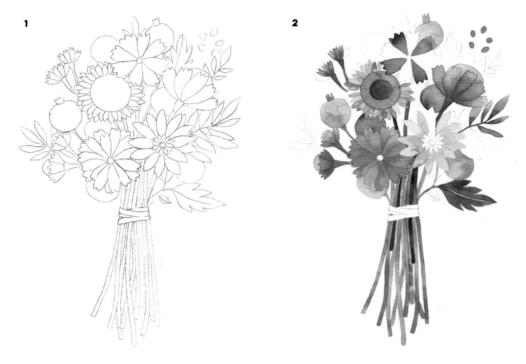

1 Start by drawing the outline of your bouquet. Keep your drawing as simple as possible; details will be added later with watercolor layering.

2 Begin painting your initial layers. Keep in mind it's best to work around your entire composition while you wait for certain areas to dry, like what we did with the daisy activity, but on a larger scale. For example, don't concentrate on painting the sunflower entirely before moving on to the stems. Start with one stem, then go paint one petal of the sunflowers, and so on. This allows the areas to dry before painting the shape next to them. This will prevent paint bleeding from one shape to the next, which is the illustration-style watercolor technique we are mostly using for this book.

3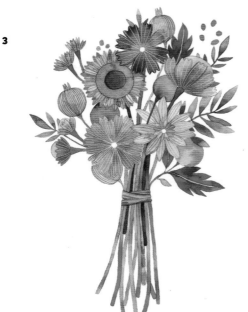

4

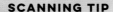

SCANNING TIP

– – –

If you plan to scan your paintings (see page 42), be sure to do it before you add embellishments. Metallics don't scan well, and the thickness of the rhinestones will prevent your scanner from closing properly.

3 Base layers are finished and now we add detail! This is always my favorite part. It's when you see your painting really coming together, and we begin to tie it all in. I used both watercolor and white ink to add detail at this point. If you are still having trouble getting those fine lines to look nice and consistent, go back to the pulse and precision exercises (see page 34). They really help!

4 It's fun to draw a few extra details with a pen or marker. This mixed-media style can make our painting more interesting and allows us to add even more detailed elements. I used a black Pigma Micron pen in this case, but you can experiment with whatever you have. I highly encourage experimenting and playing around with supplies. There are no rules!

5 And finally, embellishments! This step is optional, but is loads of fun. I decorated selected areas of my flowers with gold paint and placed some tiny rhinestones in centers of my flowers using glue and tweezers.

LUSH & LEAFY PLACE CARDS

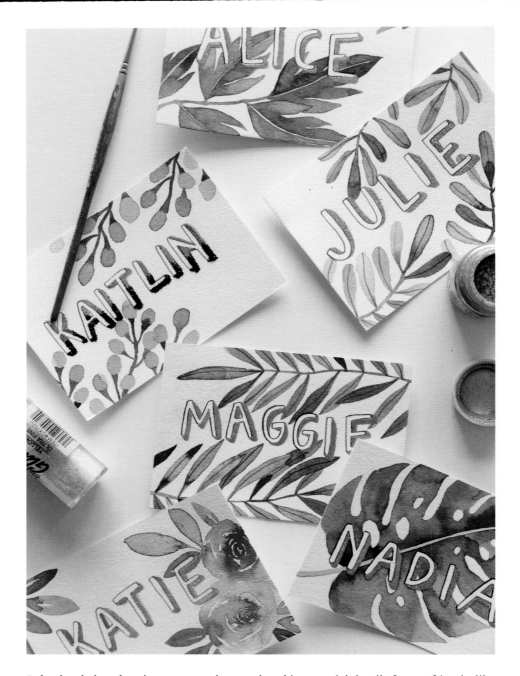

I absolutely love hosting get-togethers and making special details for my friends, like these fun tropical place cards with names embellished with glitter and gold dust.

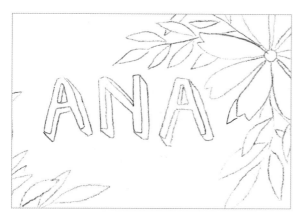

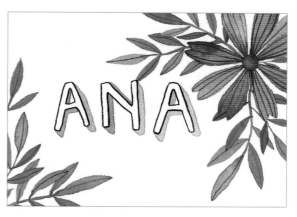

1 Give the lettering style you use for the featured name some dimension (refer to page 118 for some ideas). Add some leaf drawings, too.

2 Fill in using your watercolors. I added some gold details to the dimensional area of the letters and painted it a soft ochre so the background color would be similar to the gold embellishment.

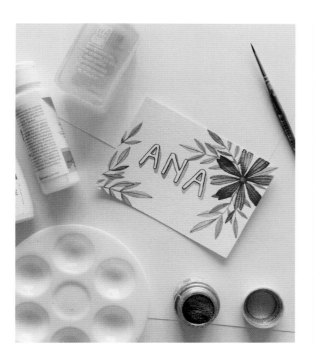

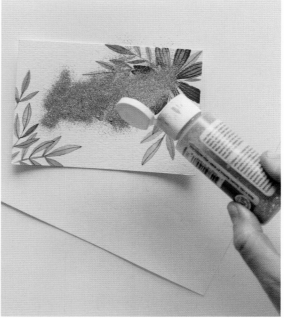

3 Wait for your watercolor painting to dry completely. Using a brush, apply some watered-down adhesive to the ochre area. Glue or adhesive that's lightly diluted with water will still be effective and will give you better control of the area you're filling out. Your glitter or gold will also lay flatter on the paper.

4 Give your sticky area a couple of minutes to dry and settle. Gently apply delicate glitter or gold dust to this area. Wait at least 1 hour for your adhesive to dry completely—or even overnight if you're patient enough.

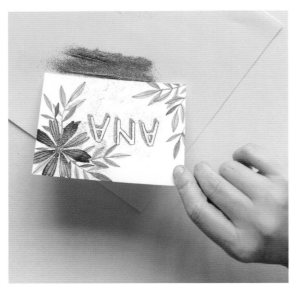

5 Tap dust into a blank piece of paper (I like recycling this stuff!).

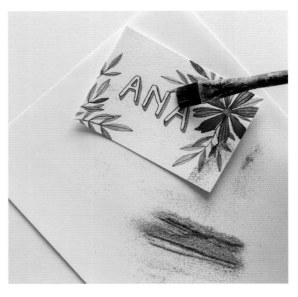

6 Brush off excess dust using a clean, dry brush.

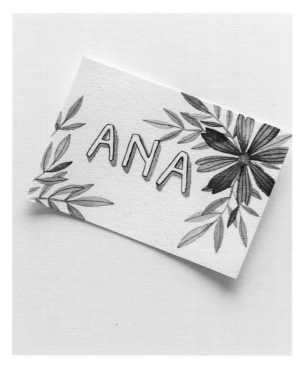

7 Now you have a beautifully embellished botanical place card!

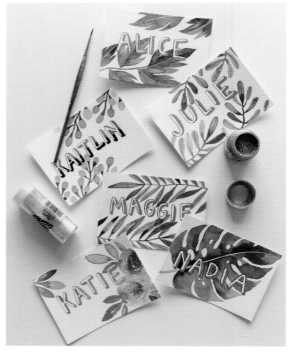

8 Repeat with different styles for all your guests.

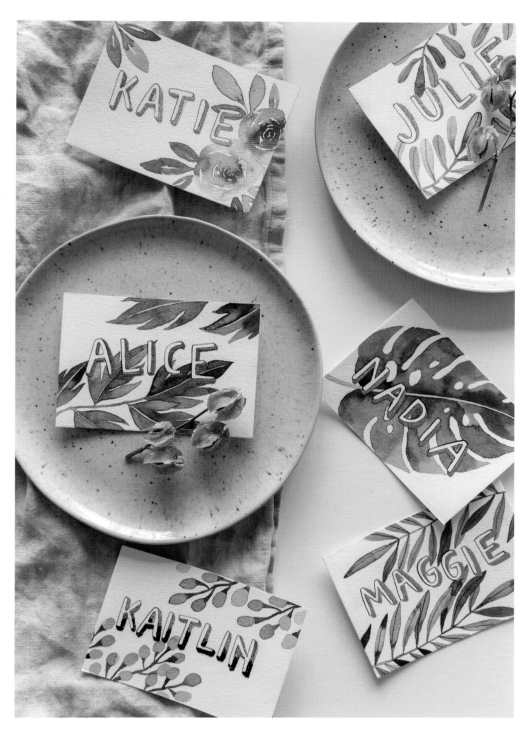

9 Set the table with each name on a plate, or use place card holders. This is a special detail your friends and family will truly appreciate and even want to take home with them.

Variations: Flowers & Foliage Place Cards

Botanical themes are endless! Can you think of more concepts? Here are a few ideas:

How about an elegant dinner party? Challenge yourself by using only **black watercolor or ink, refined branches, and a serif-style font for lettering**.

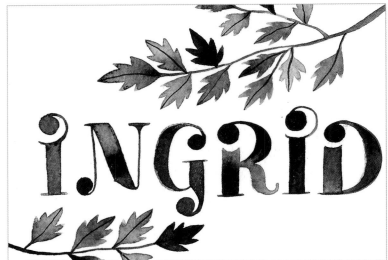

Or a playful **pink-and-green cactus concept**? This could be a cool idea for a work get-together or a teenager's birthday party. Here, we use the same lettering style as in our main project, but swap the metallics for hot pink.

Another idea is **whimsical name cards** for an afternoon of wine, crudités, and cheese with your closest friends. Use **soft color palettes with lavender tones and ochre leaves with a beautiful, breezy script lettering**.

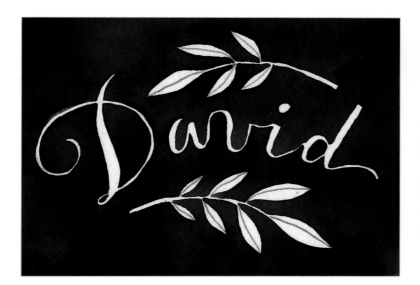

Or try a more **refined and simple place card** for a dinner party to impress. I drew leaves and the name in cursive in pencil, and then painted around my drawing with a deep mauve shade to achieve a darker look.

These are all projects you can make for those special gatherings in your life. Think of a theme and create tiny pieces of art for your guests. They'll surely appreciate these thoughtful, personalized, handmade details, and they may end up taking their names home as keepsakes!

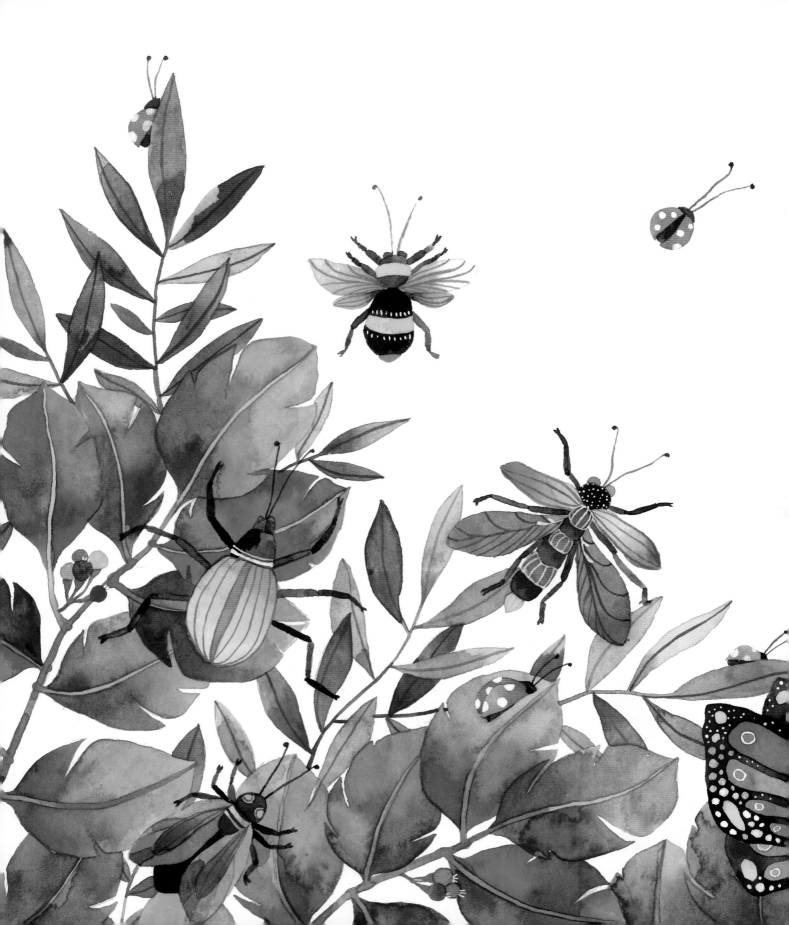

BUTTERFLIES & OTHER CRITTERS

- - - - - -

IN THIS CHAPTER, we explore different shapes and styles for painting insects. These small critters are such an interesting subject; for example, I've always thought of butterflies as dancing flowers. This chapter begins with a very practical tracing trick you can use if drawing these complex shapes isn't in your comfort zone quite yet.

DRAWING TRICK

Drawing can be quite intimidating for some, and I get that! I find the best way to get inspired is to actually observe real photographs or elements from nature and add a touch of personal style—but you may not feel this way yet. Don't worry! I have a great tracing trick for you. My goal is to keep you moving forward and not let an intimidating shape hold you back.

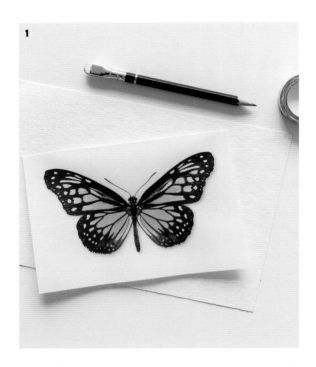

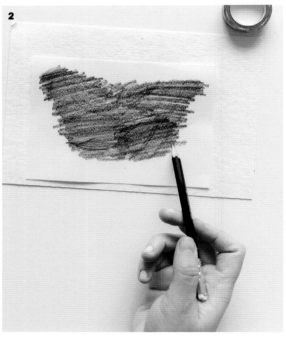

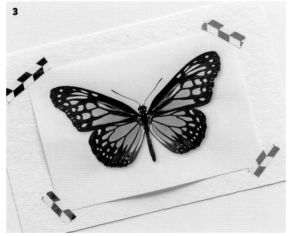

1 Find a great photograph you want to draw and print it out.

2 Flip over your printout and scribble over the back of your image using a pencil. A softer or B pencil will work best. Your scribble should be dark enough so that it will transfer well.

3 Place the image on your paper wherever you want your drawing to be, and tape down the edges so it will stay put. I like using washi tape because it keeps the paper in place but will peel off easily once I'm done.

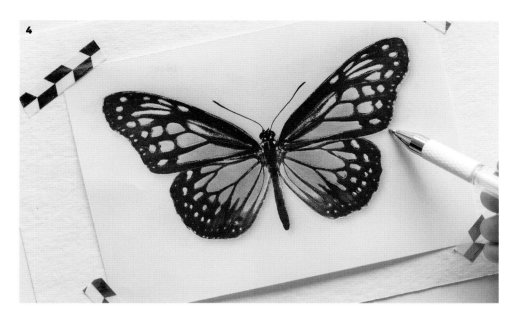

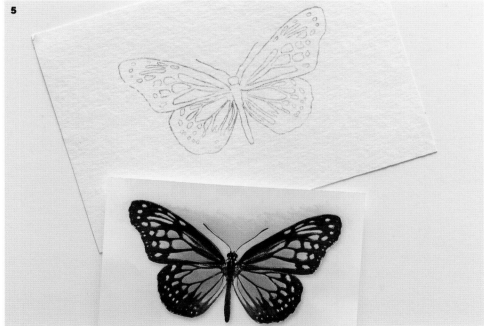

4 Using a ballpoint pen or gel pen, start drawing over your butterfly or critter outline. You may want to pick up one corner of your paper and peek to see if you're missing any elements in your drawing.

5 That's it! Remove the printed picture and you have a perfect drawing of a butterfly or critter to work with.

BUTTERFLY POSES

This section shows how to paint butterflies from above, with open wings; and in motion, in a variety of poses.

Butterfly with Open Wings

This tutorial features a classic monarch butterfly, but you can use the technique to paint a butterfly of any shape, size, design, or color combination.

PATIENCE MAKES PERFECT

When working with watercolor, it's all about finding the right rhythm so the different sections of paint don't bleed into each other. Letting one area dry before painting the one next to it is crucial when we want to create the illusion of separate elements.

1 Draw a light pencil outline of your butterfly. You can use a picture for reference or use the tracing trick shown on page 66.

2 Paint the two top wings with an orange-to-yellow gradient (see page 30).

3 Let the top wings dry. Paint the two wings with the same gradient.

4 Once the colorful layers have dried *completely,* begin painting around the pencil lines in one of the top wings with black watercolor or black ink. Either will work, but black ink will give you a more opaque effect, if that's what you're looking for. Experiment and see which you prefer.

5 Paint the other top wing, remembering to paint around all the shapes, including those little circles. If you're feeling a little shaky during this step, the exercises for pulse and precision (see page 34) will give you confidence.

6 Once the top wings have dried, paint the bottom wings.

7 Fill in the butterfly's body and antennae using the same black paint or ink you used for the wings.

8 Add details in white. I like to use white ink, but you can experiment with gel pens, acrylic paint, or gouache. If you don't have all these options on hand, work with what you have. Tiny dots along the edge of the wings add that certain *something* that really makes your artwork pop!

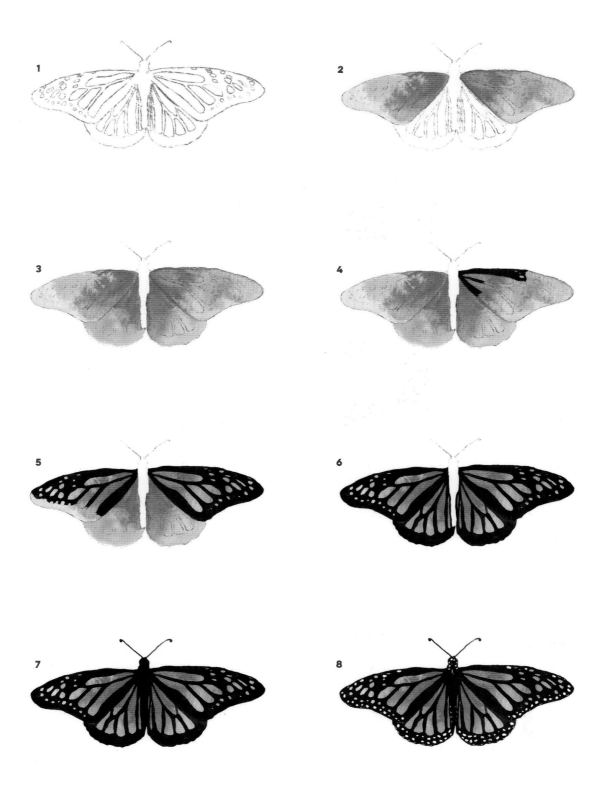

Butterflies in Motion

Now that you know how to paint a butterfly, here are a few variations in style and poses you can try. We also experiment with color and painting methods.

1

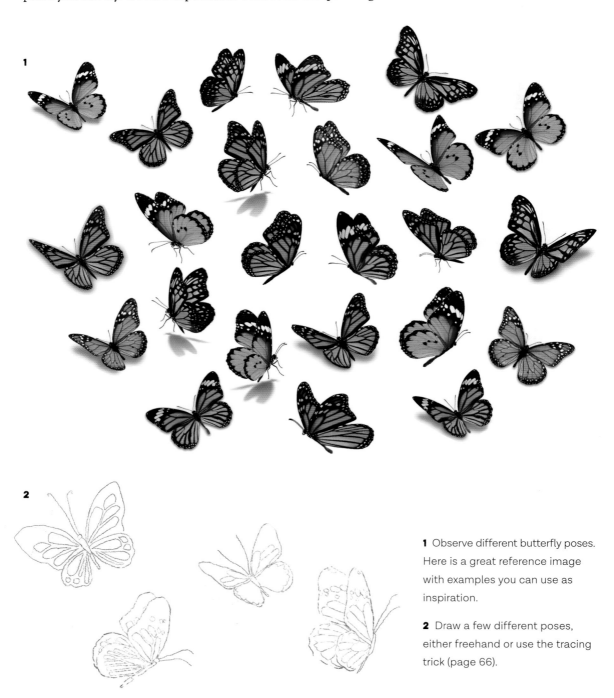

2

1 Observe different butterfly poses. Here is a great reference image with examples you can use as inspiration.

2 Draw a few different poses, either freehand or use the tracing trick (page 66).

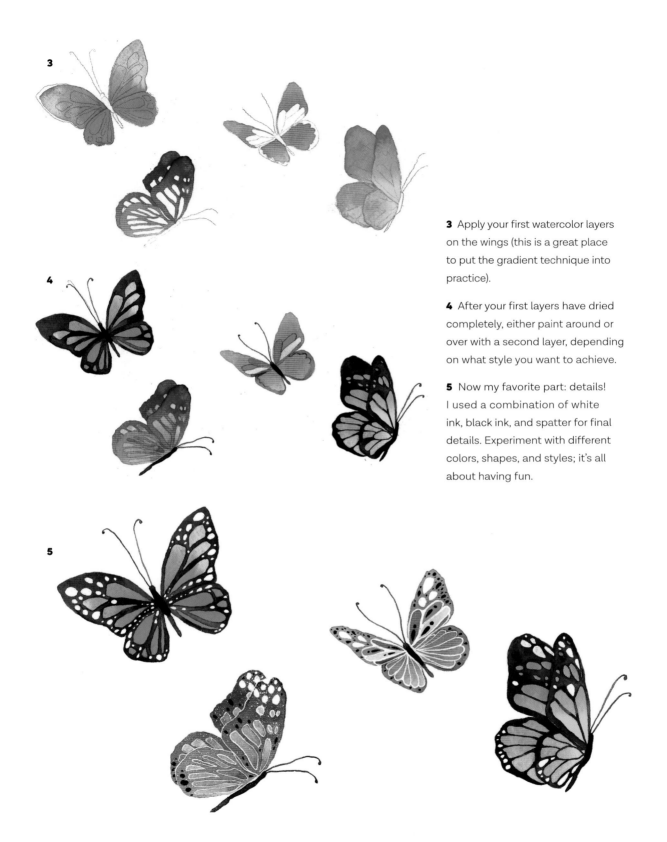

3 Apply your first watercolor layers on the wings (this is a great place to put the gradient technique into practice).

4 After your first layers have dried completely, either paint around or over with a second layer, depending on what style you want to achieve.

5 Now my favorite part: details! I used a combination of white ink, black ink, and spatter for final details. Experiment with different colors, shapes, and styles; it's all about having fun.

LADYBUGS

Ladybugs are one of my favorite insects to paint. They're actually more versatile than you might think. Usually when you think of illustrating a ladybug, a simple red circle with black dots comes to mind, but there's so much more to this cute bug! They fly, they have different angles, wings, colors, and spots. You can use the photo below for reference.

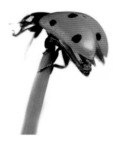

1 Start by drawing only the outlines of your ladybugs. Spots and dots will be added at the end using paint.

2 Begin painting your watercolor layers, try mixing it up with different pink, red, and orange tones. As always, remember to let one wing dry before painting the one next to it.

3 Finish your painting by getting creative with dots and spots; you can mix it up with shapes, sizes, and color. I made some spots black and some white using ink.

CREATIVE CHALLENGE

- - -

Painting a row of ladybugs is a great way to frame your artwork. Or, paint ladybugs all around the edges of your paper to add a sweet touch to an invitation, letterhead, or notepad!

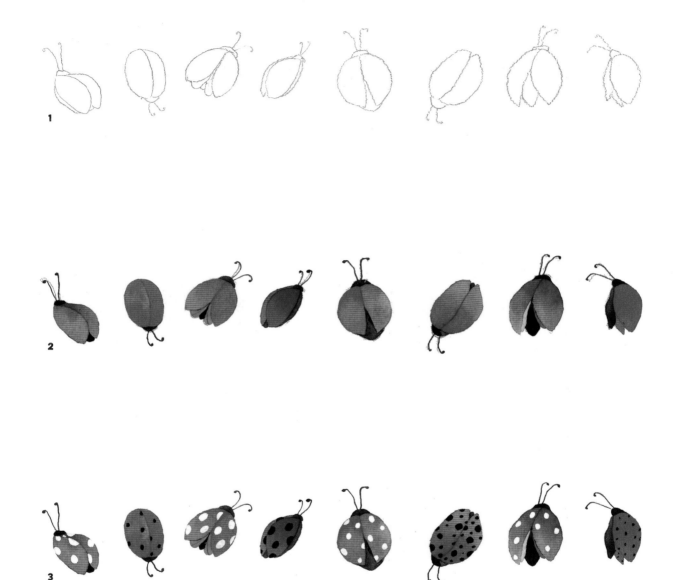

1

2

3

BEETLES

For this motif, I show how you can trace a picture and still make it your own using color and imagination. Below is the original image of beetles I used, which you can use as a reference, or you can choose any type of insect you like.

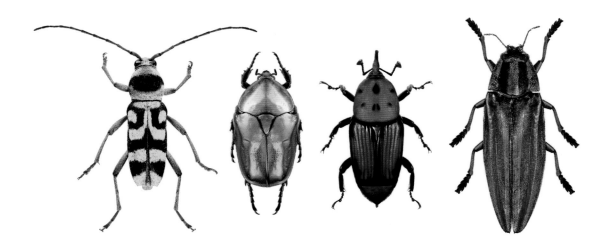

1 Trace or draw the outline of your bugs. It's great to observe the details of shapes when we draw insects. The true anatomy and composition of simple things like legs and antennae will make our illustrations so much better and will also be a nice future reference when drawing beetles or bugs in general.

2 Begin painting your first layers. Be mindful of order and allow areas to dry before painting next to them. I played around with color here, experimenting and adding personal touches.

3 Finish your illustration by adding details. I like layering texture with watercolors and adding touches of white ink to complete my paintings. Dots, lines, stripes, and other simple shapes go a long way.

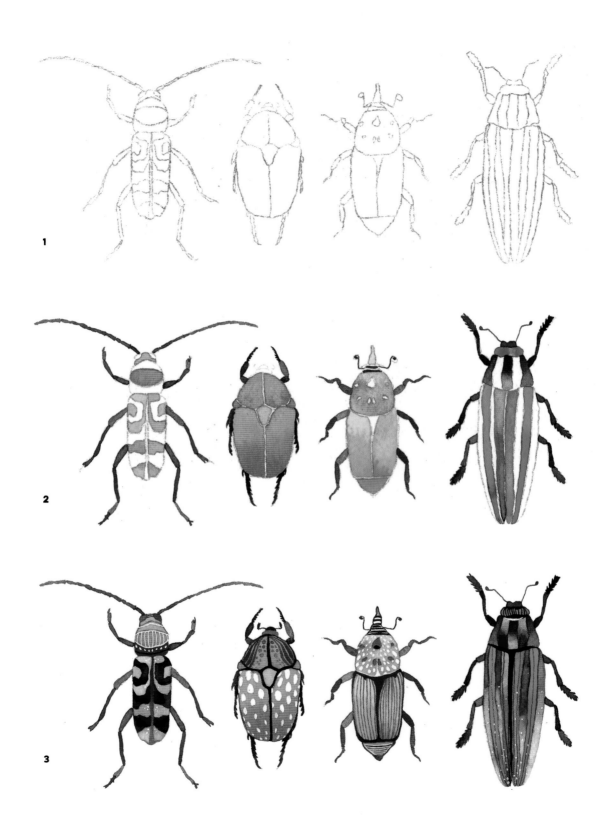

1

2

3

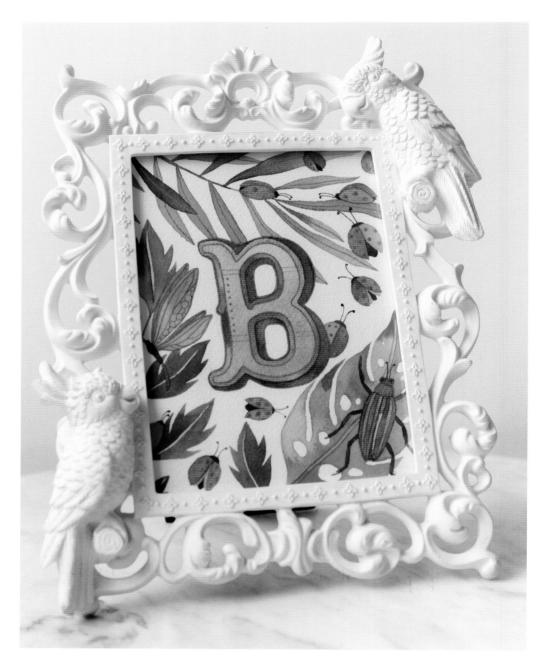

Bugs are great for kids' projects. How about painting a birthday party invitation or a baby initial to hang in a nursery? Let's try it out!

1 Start by drawing a big number or letter. In this case, I used the letter *B* and a decorative style of lettering. Draw a variety of bugs and leaves around your initial.

2 Paint your first watercolor layers. The trick is to always paint around your illustration while you wait for sections to dry.

3 When your first layers have dried, continue to fill in sections with watercolor. You can observe how necessary it is to be patient and wait for paint to dry here. In the example of the *B*, if blue paint was not completely dry, the pink border would bleed into the rest of the letter.

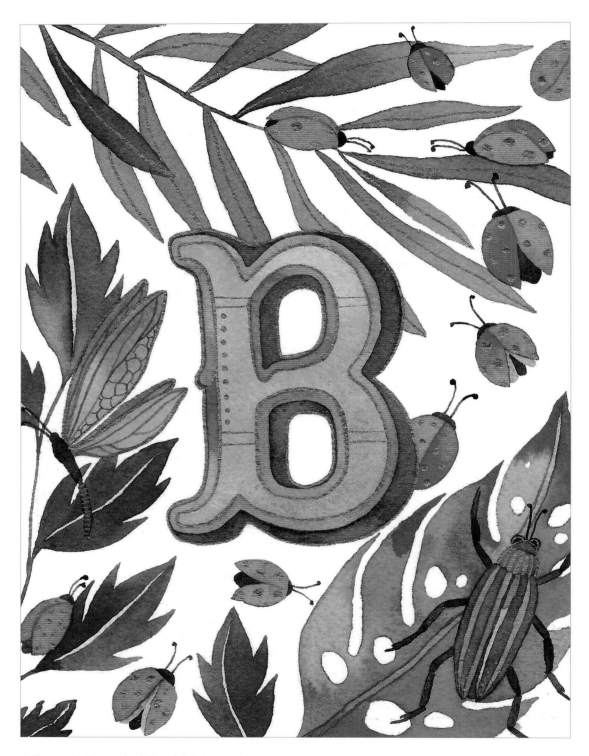

4 Keep painting and adding detail to your shapes.

5 Try using gold or metallic paint for ladybug dots and initial outline. Wait for the paint to dry completely, then display in a fun frame.

COORDINATING THANK-YOU NOTES

If you use your initial as an invitation, you can make a unique matching thank-yous by painting a watercolor border, scanning it, adding text in Photoshop, and printing out as many as you like!

Variations: Critter Celebrations

Here are a couple of ideas you can also make using critters in your projects.

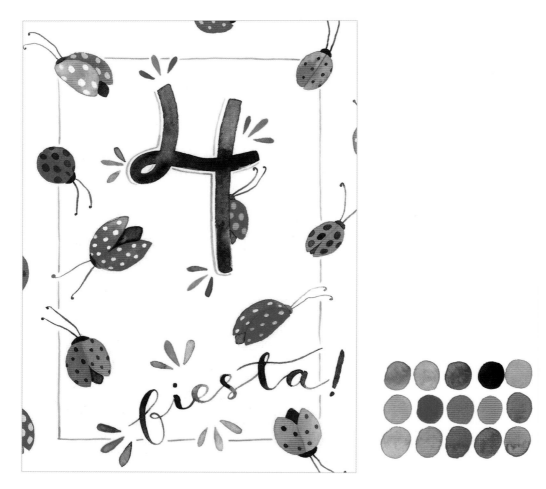

Birthday invitation. Ladybugs are bright, fun, and sweet. They're the perfect bug for a garden-themed party, whether you're turning four or forty-five! Use the tips you learned in the ladybug tutorial (page 72) to make a new composition. Draw a big number in the center of your page and scatter ladybugs all around. Scan and print as many copies as you need to invite all your guests in style. Write the details about your party on the back, or fold a piece of watercolor paper in half and have information available inside (see the Recipe Card project, page 100).

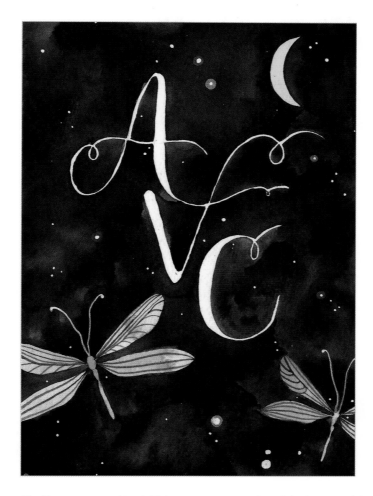

Firefly monogram. Use initials as a monogram to celebrate a special union or occasion to honor someone in your life. Here, I used *AVC* (coincidently, my fiancé and I share the same initials, so we turned it into our wedding logo). Our wedding will be on a winter night in Mexico City and fireflies seemed like the perfect *fairyish*, romantic symbol for a night to remember. For darker backgrounds like this, paint lighter elements first; in this case, firefly and Moon. Wait for these shapes to dry, then paint around them with darker blue paint. You can use white ink for lettering or draw your letter shapes and paint around them for the negative space. Make sure to practice your warm-up exercises first. You'll need a steady hand for this technique!

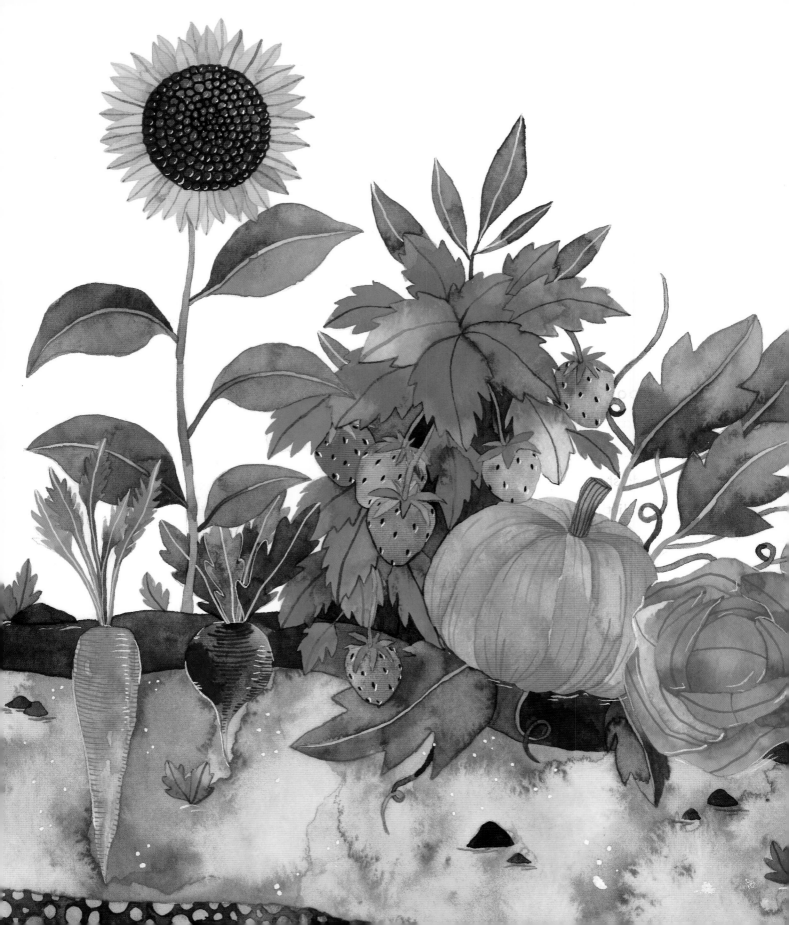

FRUITS, VEGGIES & NUTS

- - - - - - -

FOOD is one of my favorite subjects to paint. There are so many shapes, textures, and colors to use! In this chapter, I show you a slightly different method of layering, and we focus on using white ink to add shine and texture to our paintings to get a real fun, modern, and realistic style.

CITRUS

We start by painting citrus fruits with a few variations. A complete tangerine or orange, a lemon, a slice of lime or grapefruit. Our color palette will be warm and sunny—citruses always remind me of summer and freshness.

1

1 Draw simple citrus shapes. I drew a full lemon, orange, slices, and wedges.

2 Paint your first layers, lightest layers first. With this activity we learn a lot about light and layering.

3 Continue painting midtones, keeping it nice and loose, especially with the lemon and orange peels.

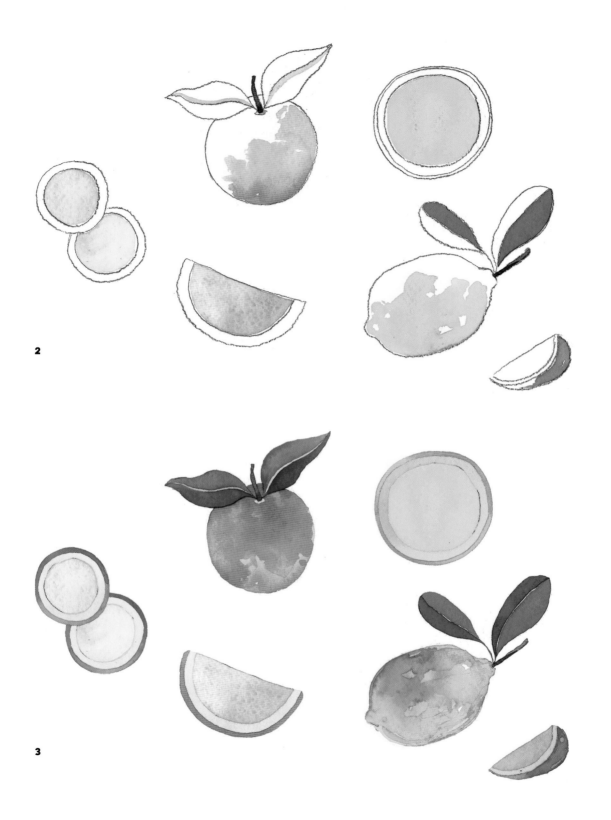

2

3

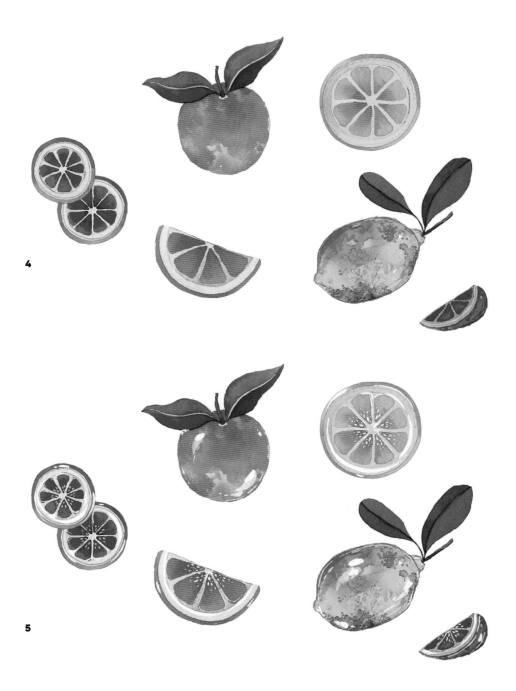

4 Begin adding depth, texture, and wedge shapes. Your watercolor will begin to get brighter and bolder as you add layers.

5 Once your painting has dried completely, it's time to add shine to your citrus! This part is so much fun. Observe and practice, be mindful of where you place reflections, and don't go overboard. Keep it delicate and use different brushes to get a nice variation in the sizes and shapes of your shiny details using white ink. This will make your fruit look juicy and realistic.

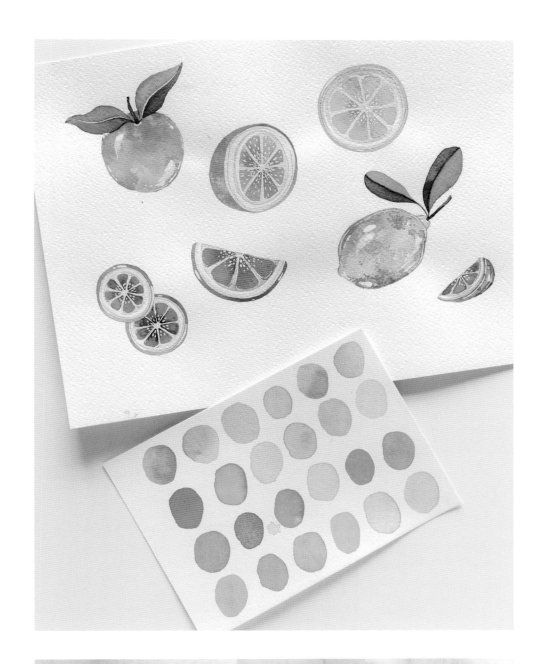

CREATING A COLOR BOARD

- - -

Before starting a project, I like to create color boards to get inspired and figure out what colors I will be using. This is the one I made for the citrus painting.

BERRIES

Berries are one of my favorite fruits to paint. You'll be amazed at how realistic they can look. Follow these simple steps and you'll get great results. I promise!

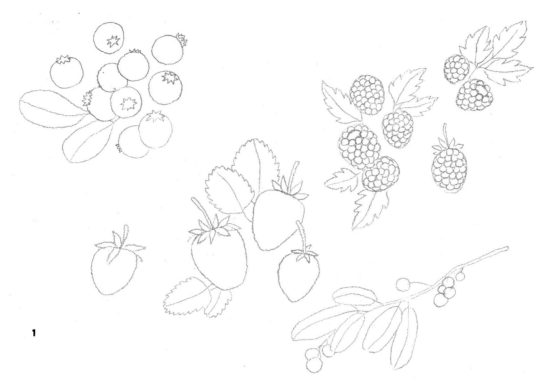

1

1 Use your pencil to draw the outline of different berries. Observe real fruit or pictures to get the best results. Sometimes, our mind has a simple image of what these everyday shapes look like, but when we look at real images we can learn so much. Here, I drew blueberries, strawberries, raspberries, blackberries, and cranberries on a branch.

2 Paint your first watercolor areas. With the blueberries and strawberries, paint a few layers to the shapes to add texture and depth; and with the raspberries and blackberries, paint little circles individually. Make sure to paint all around your illustration so you don't have to wait long for each circle to dry before painting the one next to it.

3 Continue adding watercolor layers. Have fun with your color palette and transparencies, and play around with different tones.

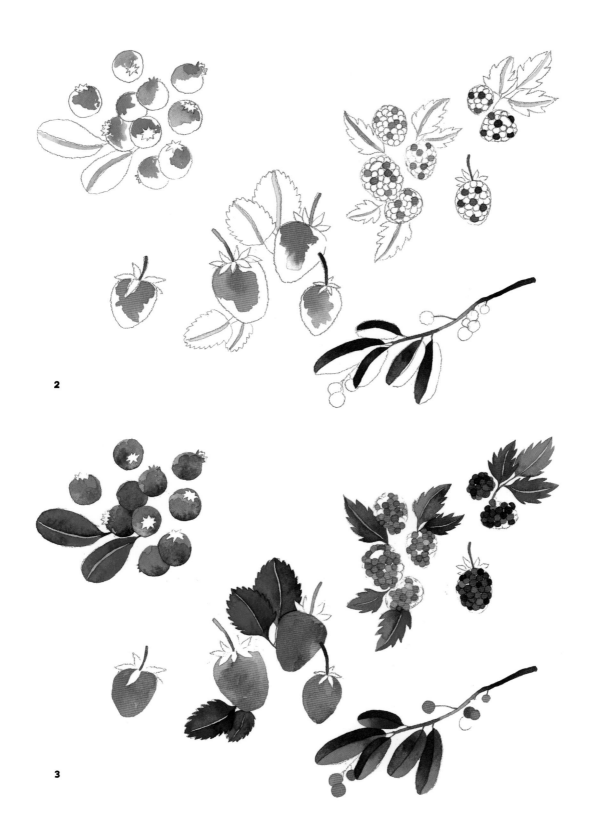

2

3

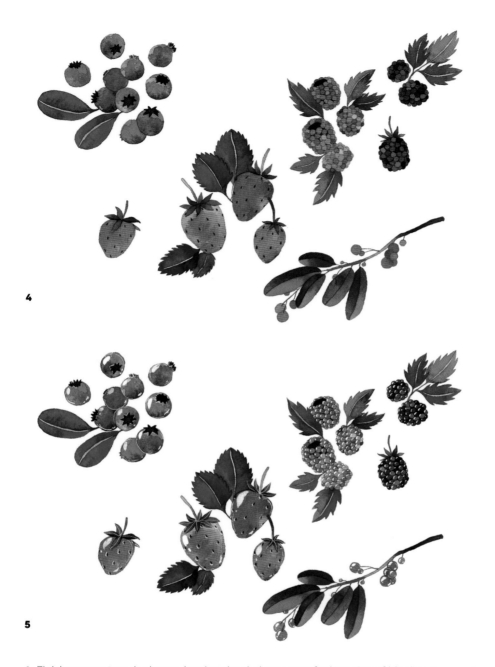

4 Finish your watercolor layers, leaving the darkest areas for last: tips of blueberries, raspberry centers, and tiny black seeds on strawberries.

5 Now: shine! This part is so satisfying because it takes our painting to the next level and is actually loads of fun. A great tip is to choose a reflection area for your painting. In this case, my shines and reflections are on the upper-left corner of each shape. Make sure to follow the natural curve of each shape to make it look more realistic. I also like to grab my fine-tip brush and paint thin lines around the shapes, just on certain sections. Use your intuition.

KIWI

In this activity, we paint a kiwi sliced down the middle. This simple shape is comprises concentric, uneven circles, beginning with the exterior fuzzy brown skin, a green gradient for the meaty part of the fruit, and a soft yellow for the core, with tiny black seeds radiating from the center. I like painting this fruit because we get to practice precision, gradients, and detailing.

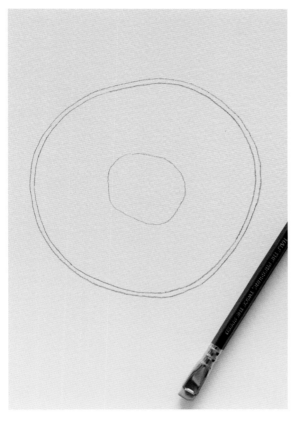

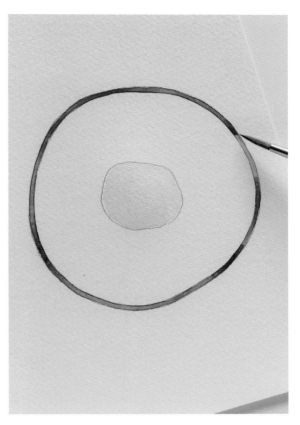

1 Draw a large circle with a smaller circle inside. The circles don't have to be perfect; your painting will actually look more natural if the shapes are a bit irregular.

2 Paint the interior circle a light yellow and outer border in light brown.

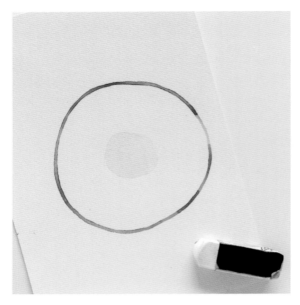

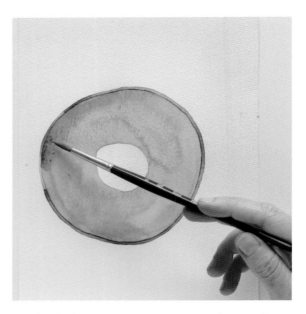

3 Wait for the paint to dry completely and erase the pencil markings. I like to clean up the illustration as I go, whenever I don't need guides anymore.

4 Fill in the large area using a green gradient, making the outer edge darker and getting brighter as you get closer to the center.

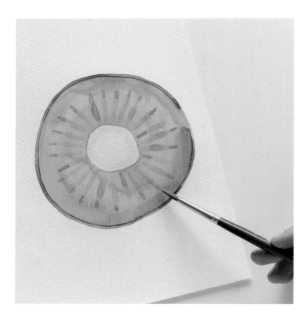

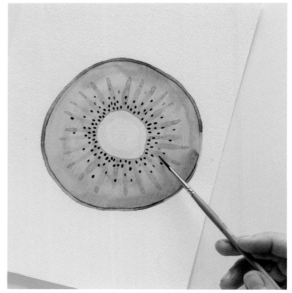

5 Using the darker shade of green, paint loose strokes away from the center.

6 Paint tiny black seed-shaped ovals following the same direction. Seeds are more concentrated toward the center and disperse as they spread out.

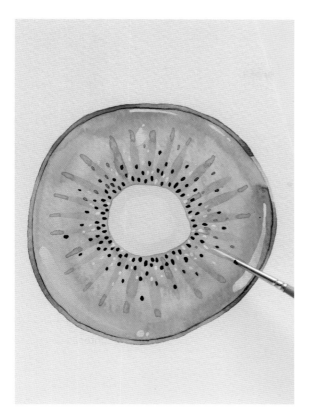

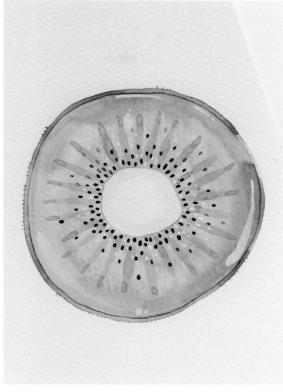

7 Add shine using white ink.

8 Paint small lines around the brown outline to give the impression of a fuzzy kiwi skin.

ALMONDS & PEAS

I chose almonds and peas for this tutorial because they allow us to artistically scatter elements. We can play with composition, begin experimenting with shadows by using different levels of transparency and opacity, and practice patience by waiting for neighboring layers to dry.

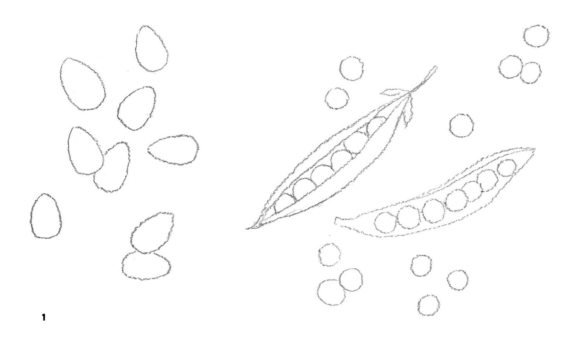

1

1 Start with a simple drawing of almonds and peas. For the peas, I drew two pods and a couple of peas on their own.

2 Paint your first watercolor layers. Notice that your first layers will always be the most transparent and how I painted just inside the pencil markings. I do this because I like my paintings to be as clean as possible. Once we paint over a drawing with watercolors, it is nearly impossible to erase pencil markings. So I like to either keep my pencil extremely light or paint just next to my drawing so I can erase as I go.

3 Wait for your first layers to dry so you can continue to paint the shapes next to the initial ones. I also erased pencil drawings wherever possible—make sure your layers are 100 percent dry before erasing! If you are not patient, you could ruin your painting. Trust me, I've done this before!

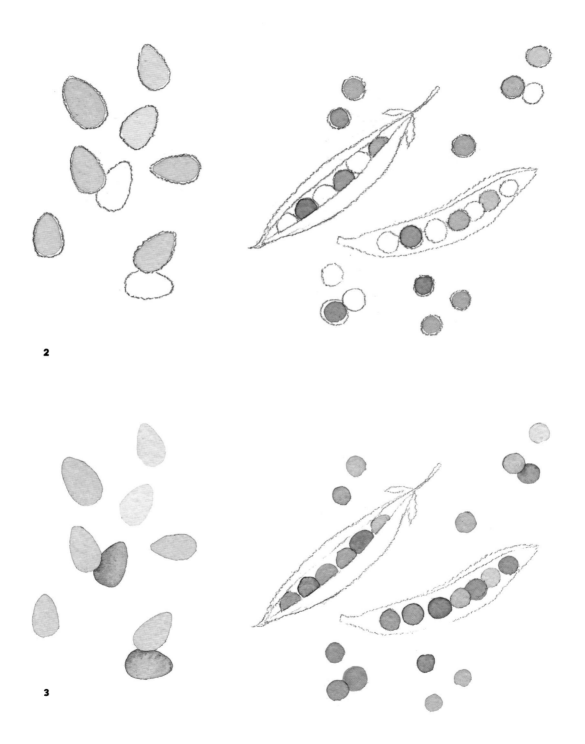

2

3

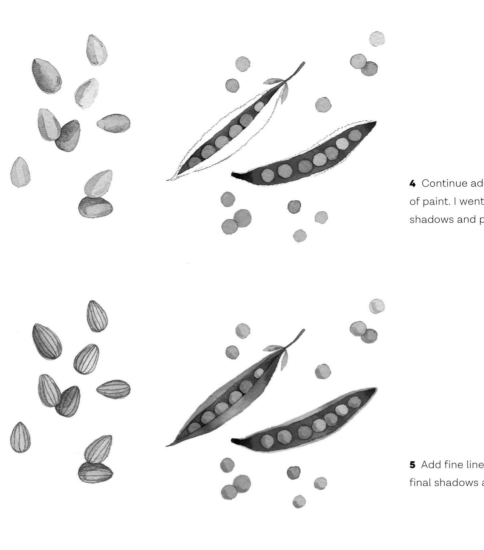

4 Continue adding darker layers of paint. I went for the almond shadows and pod interiors.

5 Add fine lines to almonds and final shadows and layers to peas.

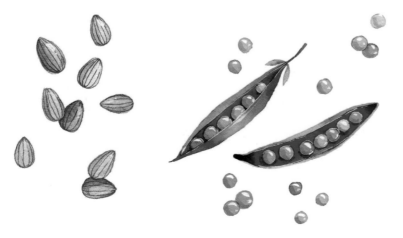

6 Delicately add details and shine using white ink.

GARLIC & RED ONION

In this activity, we work with two root vegetables that are essential for many savory recipes. Both shapes will help us practice painting volume and detailing, using fine lines for direction and applying shine for texture.

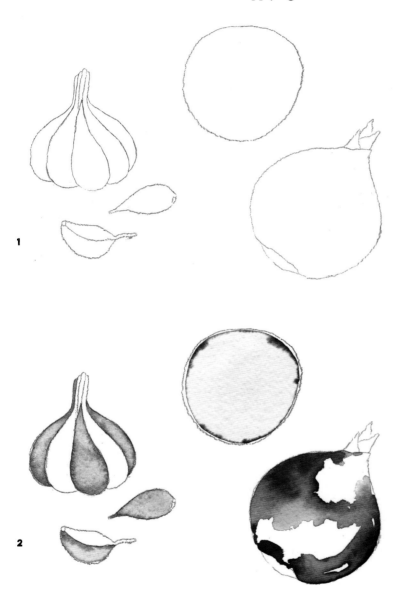

1 Draw simple shapes to outline your garlic and onion.

2 For the garlic, keep in mind each garlic clove has a roundish shape of its own. We will begin by painting each clove separately and adding a bit of color around the edges for volume. I made my onion purple, but you can choose yellow or white if you're feeling adventurous. For the first layer of the sliced onion, we will use the wet-on-wet technique. Paint a circle with light magenta (very watered down paint) and before it dries, completely pick up some concentrated paint and carefully paint around the circumference of your circle. Let it dry completely. As for the whole onion, start by painting the first layers of paint in areas where you want there to be more light.

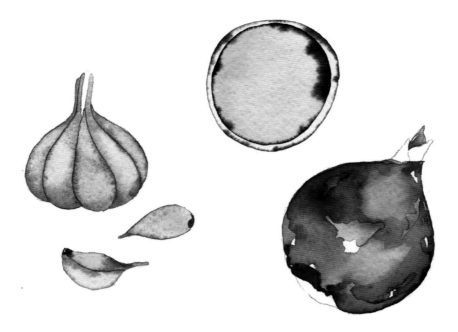

3 Continue with the last steps, making sure your first layers have dried.

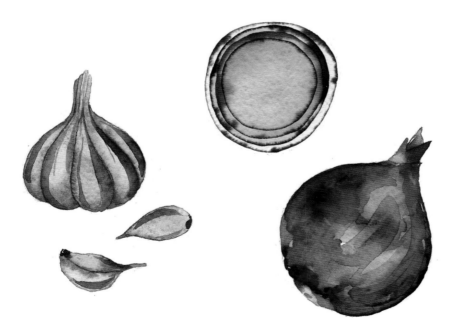

4 Now your basic areas have been covered, begin adding shadows.
For your onion slice, keep doing the wet-on-wet circle over and over again.

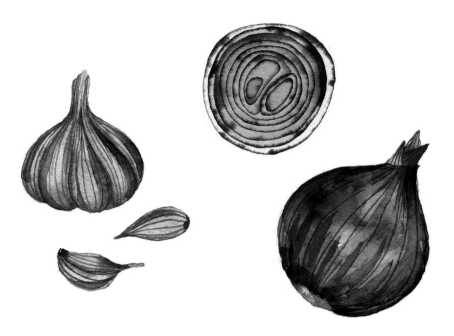

5 Add watercolor details with your fine brush. Thin strokes help with texture, direction, and depth.

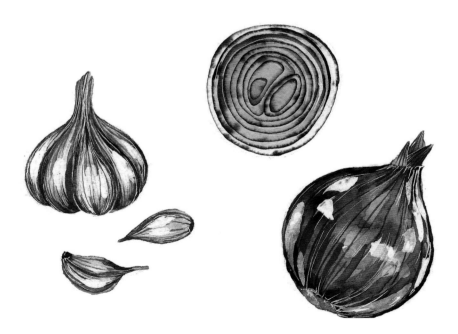

6 Add shine with white ink. I used a mix of a round brush and thin lines to add details.

STRAWBERRY JAM RECIPE GIFT CARD

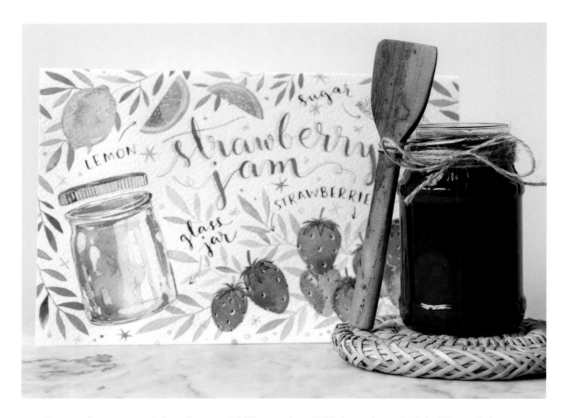

Do you have a special recipe you'd like to share? Make a thoughtful gift card that presents it in a beautiful and personal way. This project shows how to paint the ingredients for strawberry jam, but the possibilities are endless! A short list of others that would be fun to paint: banana smoothie, guacamole (see pages 104–105), apple cider, pumpkin spice cookies, and homemade granola.

You can paint a single card or scan both sides of the finished painting to later print out and make copies to give as gifts to friends and family.

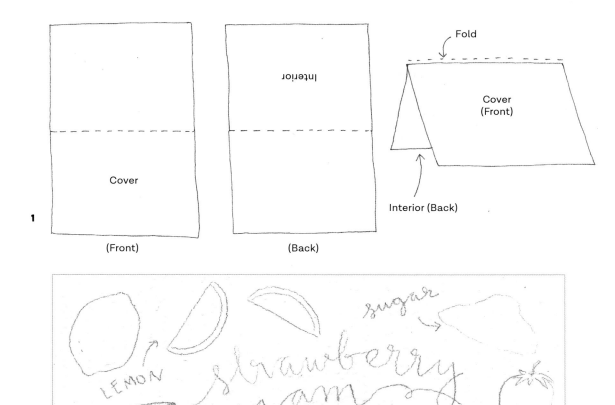

1 On a sheet of watercolor paper, lightly pencil a horizontal line to divide it perfectly in half. Step 1 shows how to fold the paper and which areas to use to achieve the desired layout for the card.

2 Lightly draw the outlines of the ingredients you want to include on the cover (front) of the card. If desired, add lettering for the title of the recipe and labels for the ingredients. Keep your pencil markings to a minimum so you'll get a nice clean painting.

3 Begin filling in your ingredients with an initial layer of watercolor. Keep in mind that you'll be painting in layers and sections, so it's best to start working on all the ingredients in the painting instead of focusing on just one at a time.

4 Once the initial layer has dried, continue painting around your composition to fill out the basic watercolor layer so that all the ingredients have a first layer of paint.

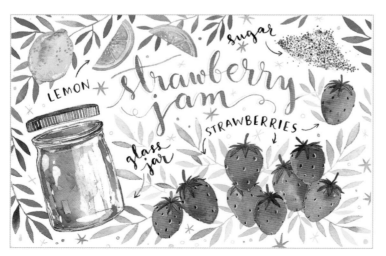

5 Now the best part: details! Adding details is what really makes a painting special and complete. For example: tiny seeds for the strawberries, little dots to give the lemon some texture, white ink to give the glass jar reflections, filling out the lettering. This part is all about feeling it out. In this case, I felt the background was too blank, so I added leaves using watery paint so they wouldn't overpower the rest of the painting.

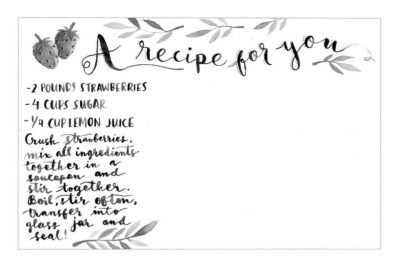

6 Once the painting is completely dry, flip the paper over and paint the interior of the card. One fun idea is to hand-letter the complete recipe and leave some space for a personalized message.

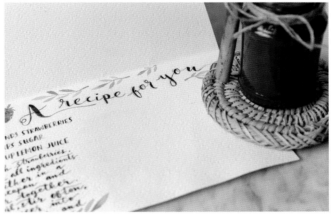

HANDMADE ART, HOMEMADE FOOD
- - -

For a superunique gift idea, make a batch of your recipe and gift it with a personalized message. You can make this once or scan your watercolor and print out as many cards as you like. It's also a great gift for holidays and teachers.

Variation: Guacamole Recipe Gift Card

Who doesn't love guacamole? It's a must at any party, especially in my home country of Mexico. There are so many ways to prepare guacamole, but for me, traditional is best. Avocado, onion, tomato, chile, lime, cilantro, and salt are the essentials. Some people like adding radish, garlic, seasoning, cheese, olive oil, cream, or spices, but for this recipe we're keeping it simple.

We can use what we learned in the tutorials from this chapter to paint the recipe completely!

- We already know how to paint **onions** and **lime** (see pages 97 and 84).
- For the **avocado**, take a look back at the kiwi we made (page 91). Painting an avocado is quite similar, except the shape is more pear-like. Instead of a core we have a pit, no tiny seeds, and the skin is darker. With a few variations, we have a perfectly painted avocado.
- As for the **tomatoes** and **chile**, look back at our tangerine and lemon (page 84) and just adjust the shape and color.
- For cilantro, look back at our leaf studies (page 48) and use a photo reference of that herb.

My goal is for you to be able to apply the techniques in those tutorials to all different kinds of shapes.

Below is a detailed look at how the layers worked in this recipe:

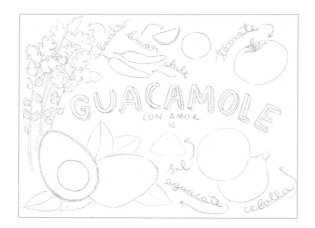

1 Begin by drawing your recipe composition using your pencil.

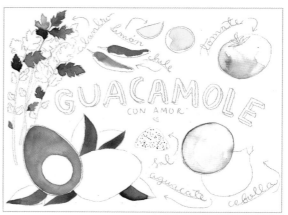

2 Paint your initial watercolor layers.

The next time someone compliments your guacamole, share your personal recipe with them by illustrating all the ingredients like so. It's way cooler than just sending over a link you found online.

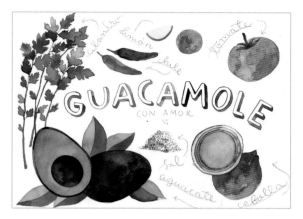

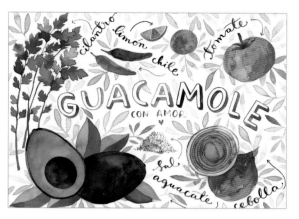

3 Continue to paint around your illustration, being mindful of how your shapes are drying and continue to layer. Use what you have learned in previous instructions for these new food items.

4 In this case, I felt the background was too simple so I added neutral leaves around the blank areas. I also painted in the black script lettering. There will be a lot of lettering tips in the next chapter.

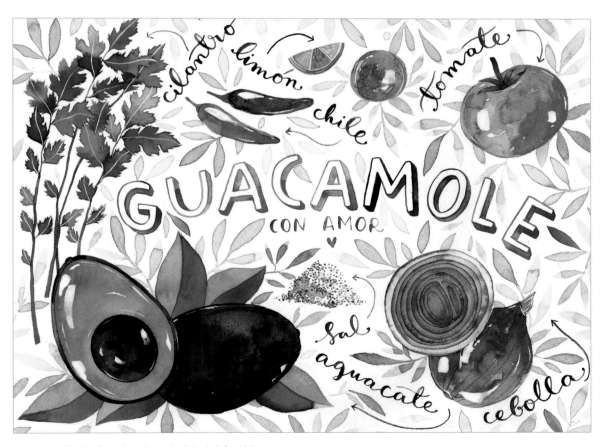

5 Finish off with fine details and white ink for shine.

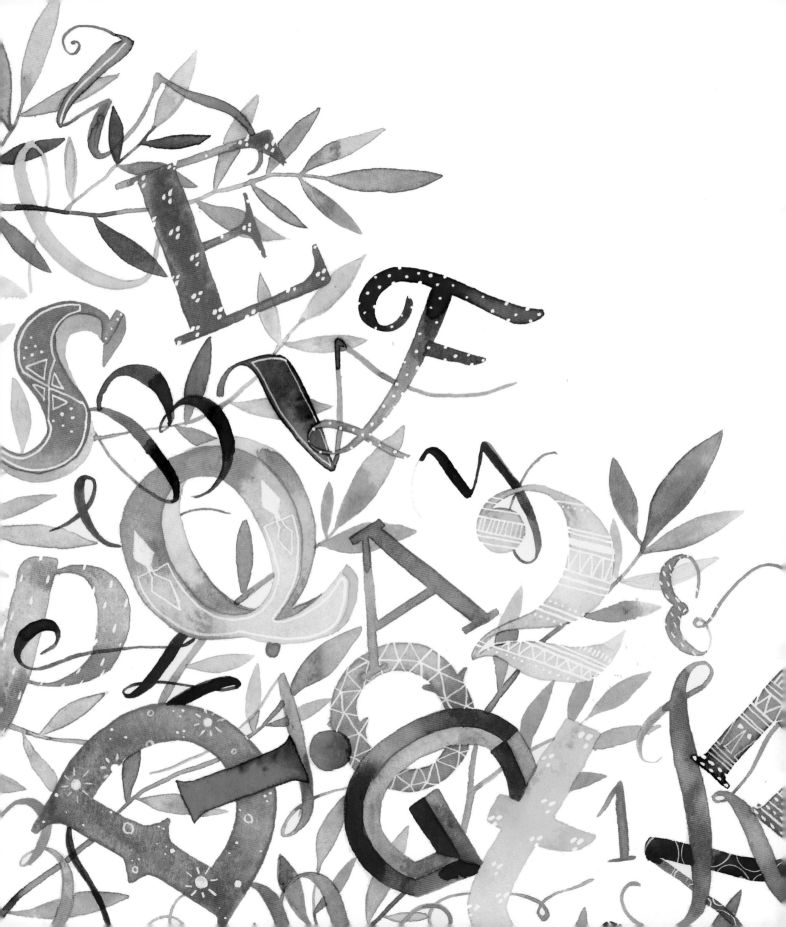

CHAPTER 6
LETTERING

– – – – – –

MY GOAL FOR THIS FINAL CHAPTER is for you to work out some lettering styles, practice, and find a style that feels right for you. Eventually, you'll be able to create handwritten words that are uniquely yours and a beautiful complement to your watercolor projects. I suggest referencing these activities when creating the projects shown in the other chapters.

BRUSHSTROKE PRACTICE

This exercise will help you warm up and feel comfortable with the type of brush-strokes we use when creating handpainted lettering. You may have to try several brushes until you find the best option. Use whatever makes you feel most comfortable and in control.

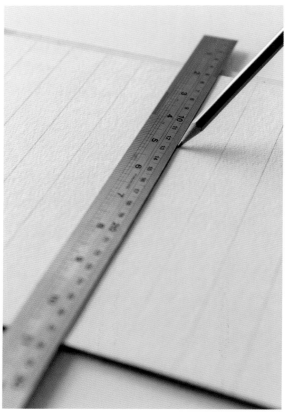

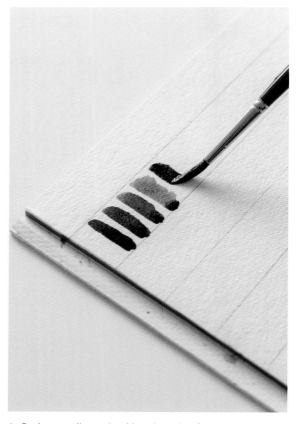

1 Use a ruler to create a series of lines about 1" (2.5 cm) apart.

2 Grab a medium-sized brush with a fine tip and start stroking down with a fair amount of pressure to create thicker lines.

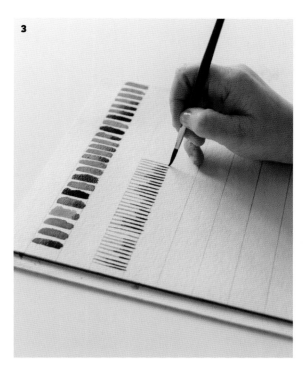

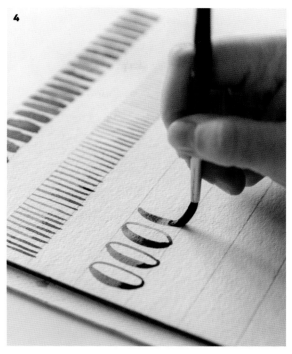

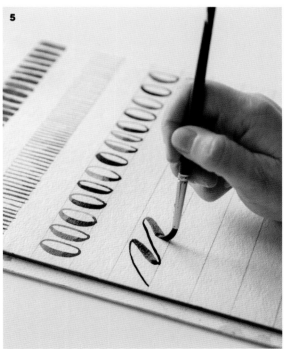

3 Using the same brush, switch the inclination to about 90 degrees and apply less pressure to achieve thin strokes.

4 Now try this same concept with a round shape. Using the same brush, stroke a curved thick line followed by an attached curved thin line, this will look like the letter O.

5 Use the same concept of thick and thin strokes, but this time, there will be no space between our shapes. This is the beginning of cursive lettering styles; your thin strokes go up and your thick strokes go down.

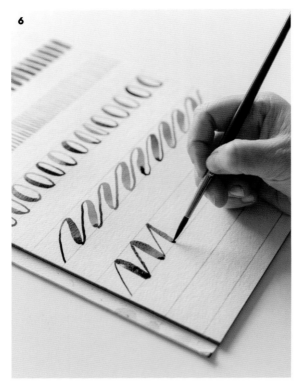

6 Try this again using pointed instead of curvy shapes. This will look like a series of merged italic *M*'s.

7 To finish the practice round, try painting a series of S-shaped lines. First apply pressure, then lightly apply the brush to create thin lines.

8 You can also play around with extrathin lines to begin to gain control of detailed forms.

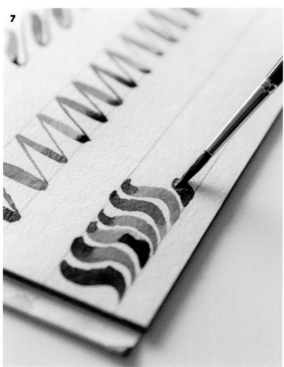

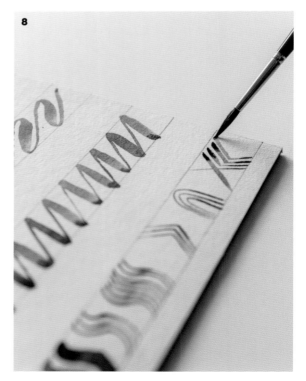

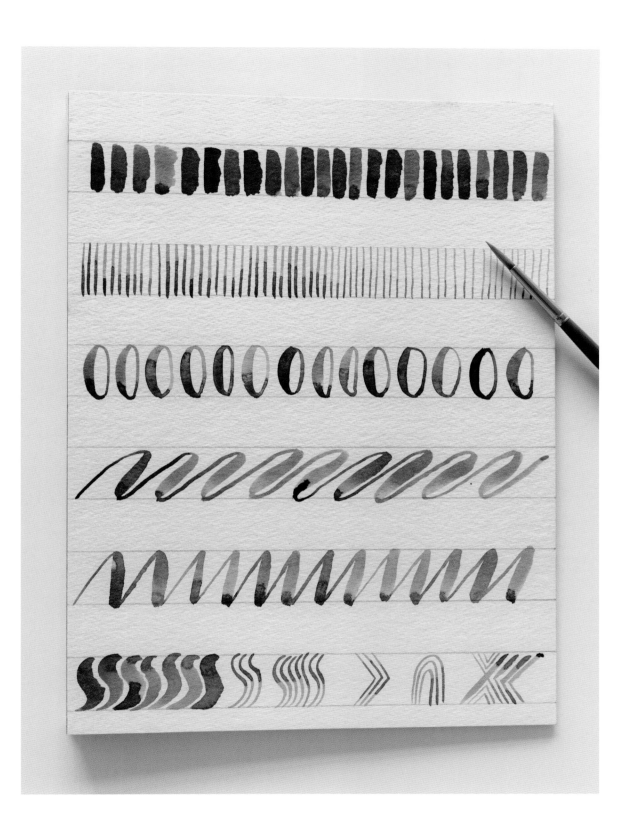

ALPHABET ACTIVITY

I love this activity for a couple of reasons:

- It's great practice and gets our hands moving without the fear of not knowing what to do next.
- It gives us ideas and helps us discover our preferred lettering style.
- By observing how different letterforms work, we can develop something on our own with handy references.

Begin by choosing a font from your computer. Create an alphabet sampler as shown in the examples below—they're the fonts I worked with. Print it out, and have it next to you for reference. These samplers can also be found on pages 130–132.

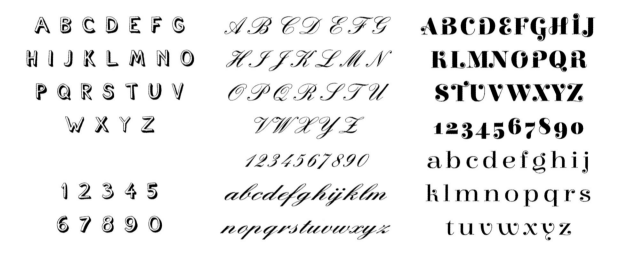

Hand-drawn block style Traditional script Modern serif style

This activity isn't about copying an existing font in your work, but for you to gain confidence, practice different shapes, and discover how letters work. I recommend doing this at least three times in different styles, painting every letter and playing around with color as you go.

ABCDEFGHIJ

KLMNOPQR

STUVWXYZ

1234567890

abcdefghij

klmnopqrs

tuvwxyz

1 Create a series of lines using your pencil and ruler on your watercolor paper. I like to space them about 1" (2.5 cm) apart, just like we did in the brushstroke practice activity.

2 Observe each letter closely and draw the outline to your alphabet. Try to use your pencil only as a guide; the less drawing, the cleaner your letters will be.

ABCDEFGHIJ

KLMNOPQR

STUVWXYZ

1234567890

abcdefghij

klmnopqrs

tuvwxyz

3 Paint your letters with watercolor. Feel free to use one color or play around with different tones. Once your paint is dry, erase all pencil markings.

4 Repeat this activity as many times as you feel necessary. Ideally, choose a cursive, a serif, and a display font.

CREATING YOUR OWN LETTERING STYLE

The ultimate goal is to create a lettering style that's all your own, true to you and only you, while using your original handwriting as a base.

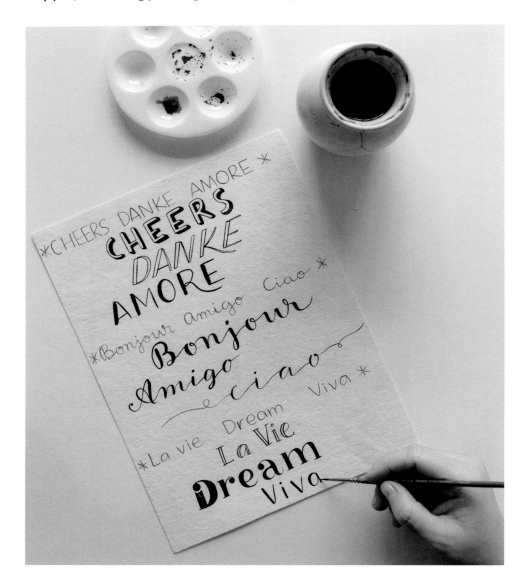

1 Separate your paper into three sections. Add ruled lines to each section. In the first section, use pencil to write three words in your regular all-caps handwriting. The second section is for your natural cursive style, and the third area is for your everyday handwriting. Pay close attention to the way to write your words. Make them nicer than when you write a quick to-do list!

CHEERS DANKE AMORE
CHEERS
DANKE
AMORE

Bonjour Amigo Ciao
Bonjour
Amigo
ciao

La vie Dream Viva
La Vie
Dream
Viva

*CHEERS DANKE AMORE *
CHEERS
DANKE
AMORE

*Bonjour Amigo Ciao *
Bonjour
Amigo
ciao

*La vie Dream Viva *
La Vie
Dream
Viva

2 Play around with each word. Think of three different creative ways you can re-create each style, maybe by making your downstrokes thicker or adding some volume. You can also write a word using the style you tried with the fonts. More ideas: Play around with the angle of inclination, spread letters apart, use swirls, add serifs at the end of each stroke—experiment, experiment, experiment!

3 Paint the lettering with black paint. Wait for the paint to dry, then erase the pencil markings completely.

Is there a style that feels best for you? What else would you like to try? Keep experimenting! There are always new designs to discover. The important thing is to create something that feels true to you.

DECORATING & ENHANCING LETTERING WITH MIXED MEDIA

Now that you've practiced with different ways to do watercolor lettering, let's experiment with different ideas to decorate your words. This is a simple, fun activity to mix in new supplies to lift up our words.

Markers for Depth

1 Start by painting a word. Here, I chose "Thank You" in simple caps. Once your paint has dried, use a marker to draw closely on the left or right side of your word.

2 Now you've created a bit of depth or shadow using a marker. Some people find drawing with markers or pens is easier to control than painting with a brush. This is always a great idea when you want to get precise by drawing instead of painting.

Adding Leafy Details with Pens

1 Paint a word using your cursive lettering. I chose *Leben*, which means "love" in German. Wait for your paint to dry and begin drawing details of leaves and twigs around your word.

2 This will give your lettering an enchanted, whimsical look, and it's another way to add very small details if you prefer drawing over using your brush.

Painting Over Waterproof Pens

Drawing with a waterproof pen and painting over it is a new method to try.
I like Pigma Micron pens the best. This method is very popular and the possibilities
are endless!

1 Start with a simple pen drawing. I chose the word "Hello" in outlined caps.

2 Paint over your drawing. Don't worry! Your pen is waterproof so the wet paint won't interfere with your drawing.

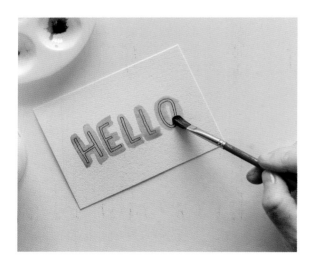

3 With this method, I like to paint in a carefree way. As long as your paint is transparent enough, your original drawing will show through, no matter what you paint over it.

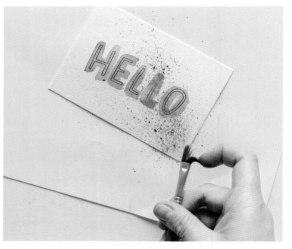

4 For a little something extra, add a bit of spatter!

Decorating with Crystals & Rhinestones

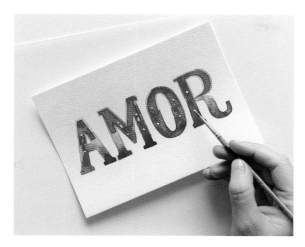

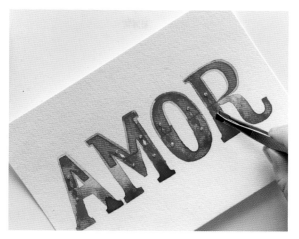

1 Paint your watercolor word and wait for the paint to dry completely. Here, I chose the word *Amor*—which means "love" in Spanish—and a Western lettering style. Using craft glue or adhesive, apply little dots where you want your crystals to be.

2 Select your crystals and get a pair of tweezers. My crystals are tiny, so I need some sort of tool to pick them up. (Fun tip: I got these rhinestones in a nail shop! Try supplies you have at home or from other crafts to embellish your projects.) Carefully place each crystal over your drops of adhesive.

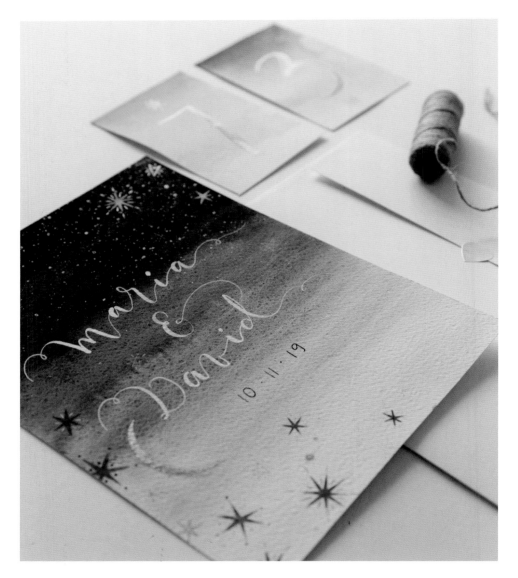

Now for our final project! Stationery goes incredibly well with watercolors and the activities we have been doing in this book. The ultimate stationery activity is creating a wedding suite, which is a grouping of different pieces—for example, a save-the-date card, an invitation, place cards, and so on—that are designed to complement each other. You could also make stationery suites for baby showers, birthday parties, fancy brunches—really any kind of event you can think of!

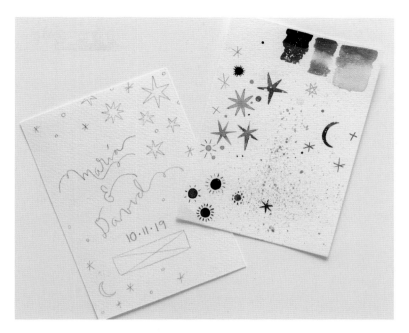

1 Before creating a piece of stationery, I like to think about the concept a bit. Consider the example of a "starry night" wedding. What would it look like? What will the layout be? What kind of colors and style will be used? I like to figure things out by first creating a sketch and making a sample or two of the concept.

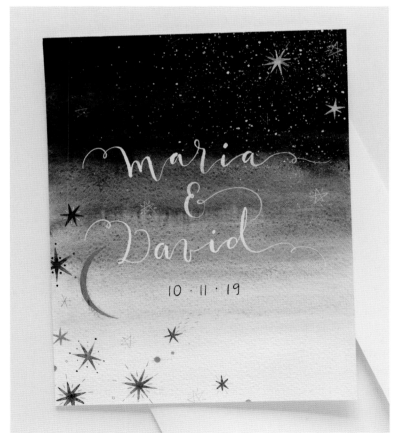

GOING PRO

If you're creating a suite for a client, making a sample concept is an excellent way to show them the look and feel of your creation before investing your time in painting the full illustration.

2 Once you have your concept figured out, continue to paint the main piece. In this case, that's the wedding invitation. Do you recognize the techniques used here? Building up color, spatter, layering, white ink over watercolor, and gold details were all used in this painting!

3 I adapted the ombré concept from the large piece to create smaller pieces for additional stationery elements using different shades of blue.

4 Once the ombré layer dried, I painted the numbers and starbursts with gold paint.

5 Use large envelopes, stickers, and twine to style your stationery suite.

What else can you come up with? You can make menus, programs—there are so many possibilities! Use your initial painting as inspiration to create as many pieces of stationery as you can think of. Your party will be extrafabulous when guests see handpainted details all around.

5

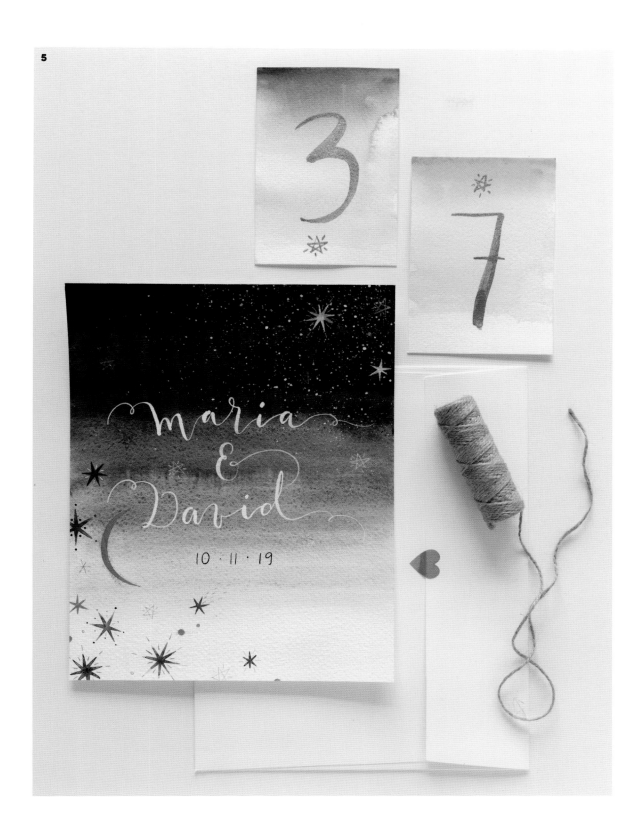

Variation: Bold & Bright Florals Wedding Suite

In our first wedding invitation tutorial, we used gradients and metallics for a celestial-themed wedding. Now, we're going for a rosy, romantic theme with a larger variety of stationery.

Our color palette is a bold and bright mix of reds, greens, and ochre. For the lettering, I used the elegant script style we practiced at the beginning of this chapter when we made font alphabets (see page 112).

Remember the very first daisy tutorial from the Flowers & Foliage chapter (page 52)? Well, these are the exact same daisies with a few variations and in a full composition. When thinking up a theme for a wedding suite, I like to have a few repeat elements to play around with for each piece of stationery. The main piece will be the formal invitation, where I have the larger, complete illustration. Then I take elements from there for a complementary theme. Basically, we have red daisies, ochre leaves on vines, and larger individual leaves in different tones of green.

For this suite, I made an invitation (opposite), menu (below, left), registry card (below, top right), and the couple's initials (below, bottom right), which can be used on thank-you cards or envelopes.

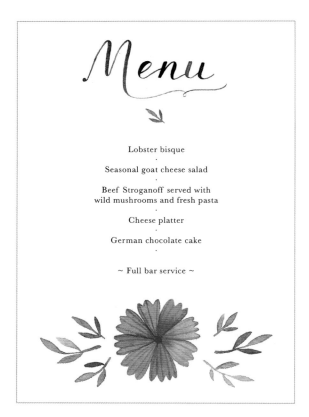

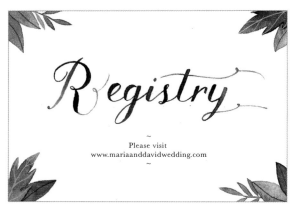

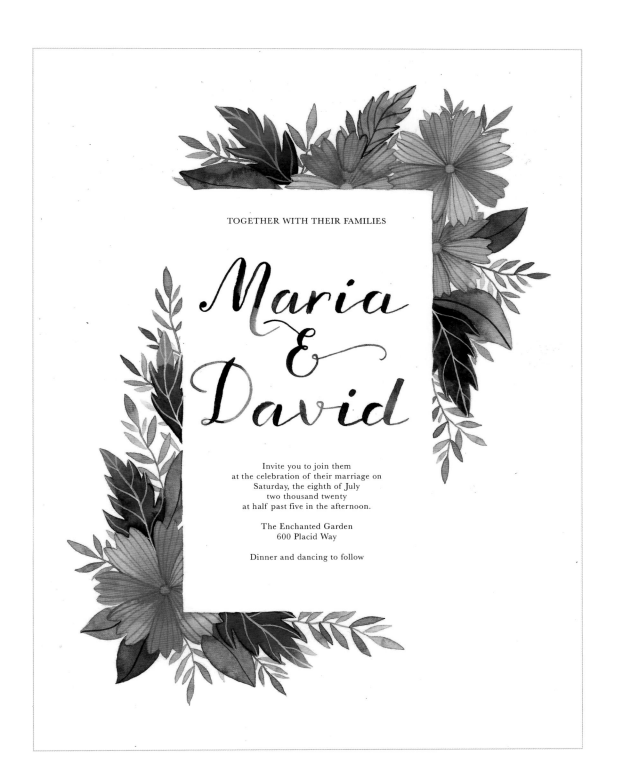

TOGETHER WITH THEIR FAMILIES

Maria
&
David

Invite you to join them
at the celebration of their marriage on
Saturday, the eighth of July
two thousand twenty
at half past five in the afternoon.

The Enchanted Garden
600 Placid Way

Dinner and dancing to follow

MORE PROJECT IDEAS

Adding handpainted projects and gifts to your life will bring so much joy! I hope you enjoyed these ideas as much as I enjoyed creating them. I genuinely integrate handmade, DIY items to my life events. Watercoloring may be my job, but my favorite projects are always the ones I end up using in my personal life and sharing with friends. These details take entertaining and gifting to such a personal level, and everyone around you will appreciate *your* personal touch.

To leave you with some inspiration, here are some projects I've made through the years:

- Family Christmas cards
- Holiday "to and from" tags
- Baby room mobiles
- DIY wrapping paper
- Gift bag names
- Welcome sign at weddings
- Table menu for Sunday brunch
- Personalized business cards
- Scrapbooking elements
- Birthday favors (re-create the wrapping of a chocolate bar and cover to make DIY candy)
- Thank-you notes

Bring an extra touch of charm to life and memories of special days with handmade projects! Experiment, play around with your supplies, and find a style that feels best for you!

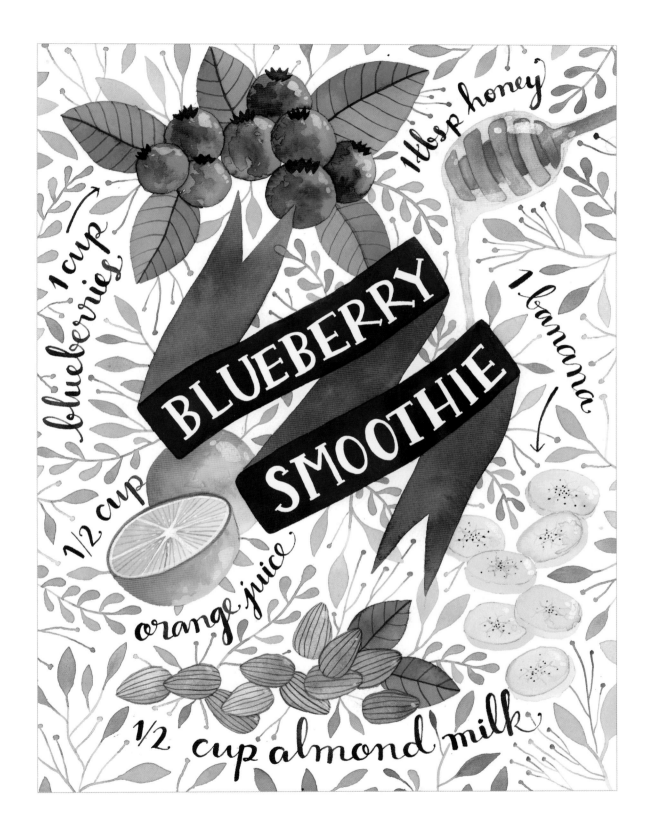

1 cup blueberries

1 tbsp honey

1 banana

1/2 cup orange juice

1/2 cup almond milk

BLUEBERRY SMOOTHIE

Hand-drawn block style sampler for Alphabet Activity (see page 112)

A B C D E F G

H I J K L M N O

P Q R S T U V

W X Y Z

1 2 3 4 5

6 7 8 9 0

Traditional script sampler for Alphabet Activity (see page 112)

A B C D E F G

H I J K L M N

O P Q R S T U

V W X Y Z

1 2 3 4 5 6 7 8 9 0

a b c d e f g h i j k l m

n o p q r s t u v w x y z

ABCDEFGHIJ

KLMNOPQR

STUVWXYZ

1234567890

abcdefghij

klmnopqrs

tuvwxyz

RESOURCES

For further watercolor instructions I highly recommend taking online lessons on **Skillshare** or **Domestika**, for Spanish speakers.
www.skillshare.com
http://domestika.org

For more information on supplies:

Arches Papers
www.arches-papers.com

Canson
http://en.canson.com

Copic
https://copic.jp/en/

Daniel Smith
http://danielsmith.com

Dr. Ph. Martins
www.docmartins.com

Holbein
www.holbeinartistmaterials.com

Kremer Pigmente
www.kremer-pigmente.com/en

Pigma Micron
www.pigmamicron.com

Schmincke
www.schmincke.de/en.html

Sennelier
www.sennelier-colors.com

Winsor & Newton
www.winsornewton.com

ACKNOWLEDGMENTS

I feel incredibly fortunate to have been born into a family setting where creativity bloomed. Without knowing it, my mom formed two artists by making our birthdays magical sand-castle contests and filling our room with all the colors and supplies imaginable. My dad, for never doubting my artistic path and supporting me 100 percent until I was ready to fly on my own. To my sister, for living in this fantasy world with me, for all the talks and for just getting it. To my parter, who is *so* smart and looks up to me as much as I look up to him. Thank you, you are my pillars.

I also want to thank all my amazing friends and mentors who have supported my career and are always enthusiastic about collaborating and making magic together. To my aunt, who bought half of the pieces I made at my first art fair, I will never forget that. To everyone who sends me pictures and gets just as excited as I do when they spot my art out in the wild. To everyone that has signed up to take a class, workshop, or come to a retreat with me. I think about you all the time.

Last, but not least, to the amazing Quarto team, for showing interest in what I have created and guiding me though this new adventure. It has been quite a ride, and I am incredibly grateful for this wonderful opportunity.

Thank you, thank you, thank you.

ABOUT THE AUTHOR

Ana Victoria Calderón is a Mexican-American watercolor artist and teacher with a bachelor's degree in information design and continued studies in fine arts. Her licensed artwork can be seen in retail outlets throughout the United States and Europe, on a wide variety of products, and she also sells prints of her artwork on Etsy. Ana teaches workshops and hosts creative retreats in Tulum, Mexico, as well as guiding thousands of online students on Skillshare, where she is a Top Teacher. See more of Ana's work on Instagram (@anavictoriana), YouTube (Ana Victoria Calderon), and Facebook (Ana Victoria Calderon Illustration). She lives in Mexico City, Mexico.

INDEX